DEER CAMP

Last Light in the Northeast Kingdom

photographs and text by John M. Miller

edited by Meg Ostrum

The MIT Press
Cambridge, Massachusetts
London, England

The Vermont Folklife Center
Middlebury, Vermont

Set in Bembo and Copperplate by Achorn Graphics. Printed and bound in the United States of America.

Library of Congress Cataloging-in-Publication Data

Miller, John M. (John Morris), 1948–
 Deer camp : last light in the Northeast Kingdom / photographs and text by John M. Miller ; edited by Meg Ostrum.
 p. cm.
 ISBN 0-262-13283-4
 1. Deer hunting—Vermont—Northeast Kingdom—History. 2. Hunting lodges—Vermont—Northeast Kingdom—Anecdotes. 3. Hunters—Vermont—Biography. 4. Northeast Kingdom (Vt.)—Social life and customs. 5. Northeast Kingdom (Vt.)—Biography. I. Ostrum, Meg. II. Title
SK301.M46 1992
799.2′77357—dc20 92-3703
 CIP

CONTENTS

These are the finest photographs of hunters and the wild and remote places where they hunt that I have ever seen. It is all here: the multi-generational ritual of going to deer camp; the wonderful camps themselves, from converted school buses with stovepipes sticking out the roofs to comfortable second homes in the woods; the allure of the pickups and jalopies, of hand-drawn maps and hand-carved furniture, of polished snowshoes and inlaid rifles and smoking camp stoves and snowy wood-piles and the starkly lovely November country-side. In these pages John Miller has captured not just a sport but an era. Here are old-timers whose like will never be seen again but whose woodscraft and love of the places where they have hunted are before our eyes being transmitted to grandsons going to camp for the first time. Here are the backwoods bars and country gathering places where hunters tell their old and new stories and a whole regional mythology is preserved. Here are the fabled trophies of the great hunts, hanging from maple trees, mounted over camp mantels, or slung in the rusting beds of pickups. Here are the wives and mothers and daughters, many of whom are avid hunters themselves. Yet in the end these splendid photographs record not hunters and their quarry at all, but men and women and animals and the special place where they all live together, close to a natural cycle of seasons and weather and birth and death that most of us have insulated ourselves from. Augmented by a spare and moving personal narrative and carefully selected oral histories, these magnificent images convey—with unsentimental honesty, with great sympathy, often with humor, and always with exuberance—nothing less than a record of a way of life passed down from generation to generation since the first hunter set foot in Vermont's Green Mountains. Mr. Miller's book is a remarkable artistic achievement as well as an important historical document. We should treasure it, and him.

Howard Frank Mosher
Irasburg, Vermont

ACKNOWLEDGEMENTS

I first wish to thank the hunters who gave me their trust, even when I arrived uninvited at such a private sanctum as a hunting camp traditionally limited to family. I am indebted to them and to the many gracious individuals who offered me generous hours of both personal and work time, wonderful meals in farmhouses and mountaintop camps, and often a bed, even if it was a mattress under the poker table.

Many friends and professionals aided my research and influenced my thinking as the project developed. I owe my utmost gratitude to Howard Mosher, for his writing about the place we call home; to Philip Grime, of the Helen Day Art Center, for his thoughts on the history of American sporting and landscape art and his respect for Vermont's rural traditions; and to Barbara Franco, of the Minnesota Historical Society, for advising me to take an interdisciplinary approach to the subject. Charles Stainback, of the International Center of Photography, encouraged me to write down my experiences and some of the wonderful stories I had collected from hunting families. William H. Jordy, Professor Emeritus of the History of Art and Architecture at Brown University, was instrumental in helping me to articulate, with words and images, what moved me so during my long sojourns in the Northeast Kingdom. Thomas Altherr, Professor of American Studies at Metropolitan State College in Denver, shared his collection of published material on hunting as it figured in American literary history and popular culture.

Administrators and field wardens of the Vermont Fish and Wildlife Department gave me hours of time and many anecdotes about the life of a warden. Alphonse Gilbert, Resource Economist and Professor at the University of Vermont's School of Natural Resources, shared statistics on hunting and its impact on the fragile economies of outlying rural areas in Vermont and elsewhere in northern New England. Florence Tallman granted permission to reproduce the poem "When The Roll Is Called Up Yonder" (© 1980), written by her late husband, Clifford Tallman.

I would like to thank Roger Conover, Acquisition Editor at The MIT Press, for his sustained commitment to this project. Two institutions were instrumental in the development of this

book. The Vermont Historical Society awarded me a small grant for my field research in 1990. Also in 1990, The Vermont Folklife Center provided me with major support for photography and oral-history interviewing. The Folklife Center transcribed many hours of these taped interviews, and Jane Beck and Meg Ostrum offered superb editorial advice. I am indebted to them and to the Folklife Center for encouragement, outright support, and critical commentary. I must particularly thank my editor, Meg Ostrum, for allowing me to call at any hour, any day of the week, as the manuscript took shape. Her sensitivity to the subject and to my emotional relationship to it was indispensable during the final sequencing of the photographs and the text.

This book is dedicated to three dear women: my mother, who helped support the photography and who prepared late-night meals while taking notes as I related stories from the hunting camps; my wife, Andrea, who unselfishly allowed me to leave the responsibilities of home for three weeks in November for five years and who, upon my return, listened and cared; and my daughter Jennifer, who, because of her great love for animals, made me consider hunting from their perspective. Without my family's encouragement, patience, and provocative commentary, the photography and the writing could never have been so truthful and, I hope, responsible.

John M. Miller

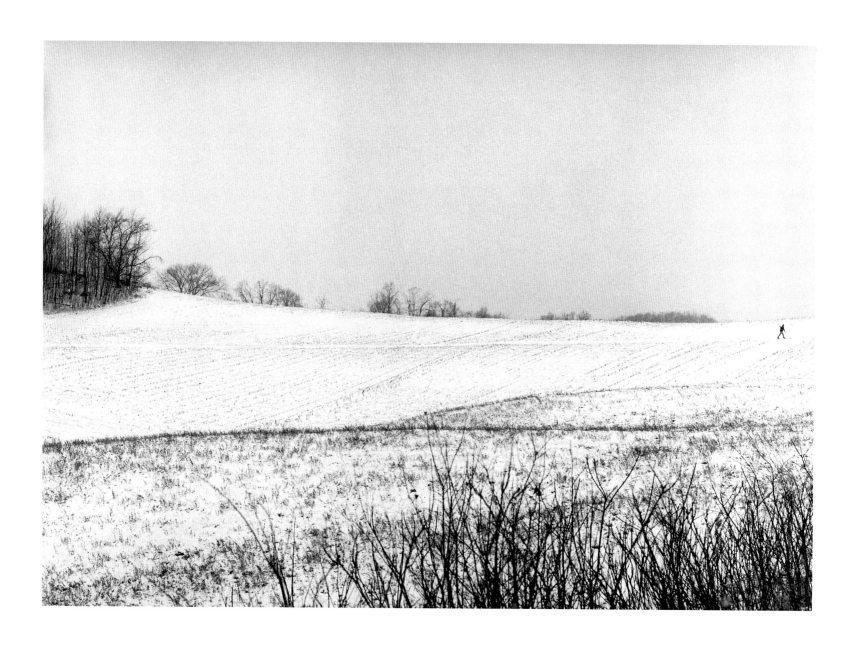

Deer Camp

The alarm clock goes off at 4 A.M. after a long Friday night of poker and reacquaintances at the Coventry Gore Liar's Club, a hunting camp in the hills behind town. My body moves sluggishly. After groping for my eyeglasses in the darkness, I lamely slide out from beneath the layers of blankets into the cold of the bedroom. I am in my childhood home in Coventry, Vermont, built in the 1840s. Feeling my way down the walls, stepping cautiously over protruding square nails and thresholds, I pass two long-abandoned bedrooms, then the one where my mother sleeps. At last I make it through the rickety paneled door into the only heated space on the second floor. Thanks to the spill of moonlight on porcelain, my aim is relatively accurate.

The full moon's brilliance, reflected off the clapboards of the next house, draws me to the window. This Saturday morning there is an observable change in the village. Dim lights seen through the frosted upstairs panes of one house are followed by illumination in a downstairs window. Sparks shoot up from chimneys as fires are restoked in kitchens. This ritual of rising had been enacted earlier by the farmers on the periphery of town, but for many of those in the neighborhood rising so early is unusual and quietly energizing.

Today is the beginning of vacation—the only block of time during the year when you can really relax while working harder and with more focus than in all the other fifty weeks combined. I look down along the main street longingly, wishing to be part of what is about to happen. If I had remained here in rural Vermont, or if I still had friends here, I would be an insider today instead of an observer. But I haven't been in the Northeast Kingdom for deer season since 1961. Now, 26 years later, I am about to begin a 16-day sojourn in the woods. I may well unearth and confront long-unattended childhood experiences and confusion. In 1959, when I was 10, my father moved to California. He packed his fly rod, his father's 45-70 lever-action Winchester, and a few carpentry tools, and he never returned to Vermont to live. Only recently, as I turned 40 and began preparing to spend most of November in the woods, did the significance of this separation stun me. This disruption in my upbringing and in our relationship was sad for both of us. This is not to leave unthanked my mother's extraordinary support and friendship. But would more time spent with my father in a healthy, natural environment have added a significant dimension to me as a person? Is this why I prefer female companionship? Fathers and sons spending extended time together has been a tradition across cultures for centuries.

These issues compel me to say goodbye to my wife and daughter for a while and return to northern Vermont to experience the familiarity of home and observe the closeness between males—fathers and sons especially.

Now showered and dressed in the first layers, I pack my camera gear, tape recorder, notebook, flashlights, compass, two kinds of film, extra socks, gloves with and without fingers (the latter for focusing in the cold), and numerous other contraptions. Last evening's indulgence makes the loaded pack frame heavier than I remember from a dry test. I get it downstairs onto the porch and return upstairs for my red plaid jacket, my cap, and the international orange hunting vest that I will drape over the frame and pack. As always when loaded for any large photographic project, I wonder why I can't simplify or reduce the number of trappings I think critical for the job. It's too late for these queries.

As I walk out into the sharp stillness, the sky is still dark. With coaxing, the car turns over and begins to idle. As I adjust my rear-view mirror, I see a couple of pickups heading down the street. I feel a quick rush knowing these people are probably on their way to a parking place in an old barway or clearcut to wait for first light, or perhaps they are going to stake out a runway deep in the woods. I quickly back out of the drive. As I approach the diner I see the trucks heading onto a dirt road out of town. I want to follow them, but I remember that I have established an itinerary for this morning that doesn't include my using my intuition . . . not yet, anyway.

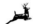

Martha's Diner is my first stop. This diner, like many in villages and cities all over America, is a watering hole for a diversity of people. They will religiously be here every morning for breakfast, which often consists of strong coffee and an earful of local gossip. The earliest group is often the haulers who must have their trailer loads in some out-of-state city by midday in order to return by evening. Then come the millworkers on their way to the furniture plant in Orleans or the twist drill company in Beebe. Some mechanics and drivers from the garage next door will be in by now, as will some of the diner's suppliers. Dairy trucks and bread vans will soon be followed by periodic deliveries of fresh donuts and pies from Irasburg.

This morning, the diner's parking lot and the shoulder of the state highway are packed with vehicles. In addition to the delivery trucks, there are orange Highway Department trucks, a couple of all-terrain vehicles, and many four-wheel-drives,

with license plates from as far away as Florida and Alabama. Most of the pickups have rifles hanging on racks in their rear windows. Besides keeping the weapon safely suspended with its muzzle facing away from the driver, I wonder if the rifle's overt location might be more about display than safety. The 30-30 of November may have replaced the 20-gauge bird gun of October, only to be replaced by the black-powder muzzle-loader in December. These guns in the windows, and the subtle transition in the colors of outerwear (from camouflage in the earlier fall to increasing amounts of crimson to blaze orange), are a shared language among hunters. On scouting trips during the past number of months I sensed that the wearing of red was as much a costuming ritual as a means of protection from the cold or from being considered a deer in the woods. (I have already observed many non-hunters wearing the same clothing. Does this reflect a vicarious connection, or an identification with past experience, or an unconscious desire?)

The booths are occupied by hunters and a few farmers. "Sis" is working the counter. I sit down between two men in hunting jackets, and the first cup of "high-test" is slid in front of me. I feel like a local when Sis asks "The usual?" (During my previous trips to the area, I always ate breakfast at

the diner, and always ordered French toast with sausage.) Most of the people around me look unfamiliar, so few of them know that I am not there every morning.

Assured by this relationship with the diner, or conceivably the waitress, I put aside most of my inhibitions and begin to scan the contents of the large accordion folder I bought to hold newspaper clippings, business cards, napkins with names and addresses, and other paper material referring to the season. I turn my attention to the most prized documents: two hand-drawn maps by an extraordinary hunter and trapper named Raymond. I know this fellow through his parents, whom I photographed at their highland farm in the early 1970s.

Raymond's preferred quarry was cats—and specifically the bay lynx, which is commonly referred to as the bobcat because of its short tail. Although he worked on his father's farm, he spent most of his spare time hunting and trapping, both out of interest and to make ends meet. So serious were these hunts, according to older hunters, that during the coldest days of deep winter Raymond would cross great stretches of territory with his redbone and blue tick hounds. The dogs might pick up a cat's track along the Black River, and after unleashing them Raymond would follow, at

a run, well up into the Lowell Range toward Eden. On occasion he had been known to snow-shoe cross-lots to Belvidere township (a distance of 10 to 15 miles), in waist-high snow, until the barking of the dogs was his only reference in the darkness. Other hunters who had picked up his tracks in Eden, about 5 miles to the west, saw an occasional piece of clothing along the trail, which presumedly Raymond had shucked after becoming overheated in the sub-zero weather. Much later, when they found him with a treed bobcat, he was in a sleeveless T-shirt. They left the clothing along the trail, knowing that if Raymond became separated from his dogs and lost the cat the hounds would always return to an article of their master's clothing, lie down, and wait for him to backtrack. Raymond's knowledge of this region spans the topography, the geography, and the inhabitants. His 40-plus years' worth of close observation of the wildlife within these 200 square miles could open the eyes of any university-trained wildlife biologist.

The two maps before me on the diner counter represent a small section of Raymond's range. They show a number of backwoods trails and logging roads, with the locations of hunting camps coupled with the name of either the camp or the owner. I visited Raymond last week to pick up the maps and discuss the particulars of the area. We had a few beers, and I was offered some anecdotes about some of the families and the camps. He told of one camp used by some brothers who, in his words, were "deer crazy":

They'd pack all the families up there for the two weeks; fathers, sons, grandsons, daughters, wives, babies, grandparents . . . even the family dog. Everybody in the woods early every morning, probably thirty of them. And deer! Party hard at night and hunt even harder during the day.

As Raymond's anecdotes about hunters and camps got wilder, I became more excited and my trepidation increased. This ridge runner had unlocked the door to a whole microcosm of hunting-camp traditions in northeastern New England, with attendant descriptions of people and places. How would I introduce myself? As a friend of Raymond? Or by saying (in reference to one of Raymond's tales) "I've heard somebody's been running bear dogs up through your hunting territory; you must be pissed off"? Or "Hello there; I'm from Massachusetts, and I want to do a project about deer hunters"? Between Raymond's two maps I had twenty or so potential contacts. Some I felt confident enough to call immediately before they went into camp. Some of the others, not yet. Rather, I'll take my front-wheel-drive car up a logging road until I've almost wedged the doors

shut with the undergrowth, hoping I haven't torn out the transmission, and somehow get the car off to the side in order not to block some yahoo coming through with four on the floor and a fifth under the seat. Then I might have to walk another 2 or 3 miles with my backpack along an abandoned road into a group of camps roughly sketched on one of the maps. What if Raymond got the names wrong? I recognized one family from Orleans. Tough, hard-drinking Frenchmen. I'd want to get there early before they had gotten too far into the sauce.

After hearing stories about the behavior of hunters who built their deer camps at higher elevations, I decided to start lower, near the flats. I brought the conversation back to the friendly deer fanatics. Raymond re-emphasized that they always have one hell of a crowd in their camp, and I resolved to stop there on the first weekend.

Driving back down off Raymond's mountain to the highway, I went over the list of those I'd have to contact before they went off to camp. As I returned to the pavement in the valley, I felt that I had left an earlier way of life for the softness of civilization. These were the paved byways along which visitors and part-time residents sped, looking ahead to the next attraction and unaware of the geographic or the cultural heartbeat of the area. After talking with Raymond and learning of the seasonal subculture of the forest and the high country, I realized that, although I had spent my first 18 years in northern Vermont, I had never lived like these people who were at peace only on the tops of the ridges. As I longed for this rural lifestyle, my passion for this area was being rekindled. Through this adventure, I could expand my knowledge of myself, and of men, and heighten my awareness of the power of the hunt in northern Vermont and of the basic human need for this pseudo-religious experience and annual celebration.

Waiting for my breakfast, I think about other conversations I have had over the past two weeks. One of my first phone calls had been to an old friend, to ask what I could bring to the spaghetti feed at the Liar's Club the night before the opening of the season. He had mentioned some of the people from the surrounding camps in the Gore who would be stopping in. I recognized many of the names, and some of them triggered great memories of wild late-night rides in search for girls or a bar up over the Quebec border in Highwater or Rock Island. Embarrassingly, I had to ask for directions to the camp. I hadn't been up on the old road to Kidder Pond for almost 30 years. I knew the dam where the road split, but I

didn't realize that the Liar's Club was a mile further, over stream beds, dead trees, and rocks.

Gaston, one of the brothers whom Raymond had recommended, had been terse but friendly. He was excited by my intentions, which I fumbled through on the telephone. He asked that I call his brother and relate our conversation. He hoped his brother Marcel would be as accepting. When I reached Marcel, later that evening, he wanted to know more, not out of curiosity but out of caution. Was I working for one of those animal rights groups? Would I write a story and take photographs of deer at their camp and tell where it was, so that next year half of Burlington would flock to their woods, figuring there must be herds of bucks in the vicinity? Gaston's referring me to Marcel suggested that Marcel was the camp boss or "don." I hadn't known about this hierarchy within a camp, but later I discovered that every camp appears to have someone in charge. It might be a grandfather if he stays at camp for the duration of the hunting season. But if he comes and goes and the eldest son remains, the son will usually be considered the elder—the one to turn to for knowledge, the master of storytelling, and the technical planner for each day's hunt.

After extensive questioning, and after the realization that we shared some friends and acquaintances, most of whom were hunters, Marcel finally invited me to stop over on the first weekend. My conversation with Marcel was a rehearsal for many ensuing phone calls: outlining some of my intentions, talking about photography, mentioning hunters with whom I had contact (such as Raymond or Wallace from the Liar's Club), and revealing my native status.

From all the preparatory work, I am already tired and stressed. I have been successful in developing a number of invitations to visit people at their homes and camps. Would further invitations diminish after the first few days of deer season? Would I be invading people's privacy? Admittedly, this was a given. For an outsider to ask to enter these sacred spaces and times is presumptuous, bordering on rude. Bringing along a camera and photographing the ceremony is even more intrusive. Packing a tape recorder might close the door permanently for future research. I am about to begin a project with the very best of intentions. I want to be sincere, honest, and non-exploitive, and to tell the truths about people who, for many generations, have maintained respect for natural things, be it the woods, conservation, animals, or one another. Even though I believe in these same virtues, I am not automatically entitled to just drop in, take their time and stories, leave, publish

a book or have an exhibit, and invite them to the opening or sell them a copy. And when the project is over, will I say goodbye to those who will have sincerely offered me warmth, food, and spirits of all varieties, but mostly time taken away from hunting? Good God, I'm not even a hunter, so I don't understand exactly what these men are feeling. Nor have I remained in and around the woods most of my life. I didn't serve in World War II or Vietnam. Blood makes me queasy. And, although I maintain a few close male friends, I often find men and their attitudes wearing. Knowing that I am about to enter a predominately male domain, I hope to get beyond my preconceptions to what I believe could be a far more positive notion of the male in Western civilization: the gatherer, the protector, the storyteller, the naturalist.

One of my last stops before the season began was to visit the gun and ammo dealer in Newport to check the buck pool for names of large hunting families. The parking lot of Mr. O's shop had a line of vehicles waiting for parking spaces. Inside, most people were purchasing hunting licenses, trading stories, and making plans to visit one another or the Bear Mountain Motel. The motel, with a restaurant, a bar, and a large dance hall, is on the lonely stretch of road between Island Pond and New Hampshire. Thanks to hunting season,

during two weeks in November it transforms into a booming business where (it is said) booze and women flow.

"We've got a beautiful 270 this year for the drawing," Mr. O said as he handed me the bolt-action Remington from the rack behind the counter. "Pretty rifle, light, not bad in brush, hard hitting at long distance. Not a pain in the ass when you've humped over two or three ridges by nine in the morning."

I handed back the Remington to Mr. O. The buck-pool registry was of much more interest to me than the rifle. Turning the pages, I felt at home as I recognized names from grade school. There were names of people who had long ago moved to Florida, the Carolinas, Maryland, Delaware, New York, Massachusetts, or New Hampshire, and who like me had come back for hunting season. The first names of some of those listed included Herman, Wyatt, Coon, Zing-Zing, Buck, Frenchy, Butch, Stub, Shorty, Tree, Skinny, Chub, and Tug. I saw the names of Gaston's family. Just as Raymond's remarks suggested, they took up about 50 lines. And more large French families filled other pages, their names often penned by one designated representative. When a surname appeared two, three, or four times with different first names, I asked Mr. O if these repre-

sented different generations. He nodded. He also told me who was the senior member in a group, and if the family had a hunting camp. He couldn't always pinpoint a camp geographically, but he had heard that one was "down in Ferdinand," one "out on the Yellow Branch of the Nulhegan," and one "two miles up a trail from Unknown or South America Pond." Even he is fascinated with the diffuse, limited directions available to these revered wilderness locations. Actual routes are available only to the closest friends and family. Without guidance from a camp member in daylight you could get lost for days.

"Remember," he cautioned, "those are the big woods. You can walk for miles and never see another hunter or road." Only the locals hunt much of the deep country, for their fathers and grandfathers were often full-time trappers or loggers who taught them to negotiate such primeval areas. Only they feel confident enough to travel off the roads and deep into the interior.

I am tantalized by the mysteries of the camps in the woods, far removed from civilization and accessible only through close friendship and camaraderie.

After Sis delivers my French toast, I put away Raymond's maps. The fellow at the counter next to me greets another local farmer who arrives for coffee and asks him if he is going to hunt this morning. The farmer replies: "We farmers work all the time. We can't get out." The hunter responds jokingly: "I hear a lot of you farmers would do anything to get out!" The diner crowd laughs, as does the farmer with much irony. Sadly, many of the farmers may hunt today. They have plenty of time now, having sold their herds at auction or through the federal buyout program. They may now be unemployed, or driving trucks. Unemployment has always been higher in the Northeast Kingdom than in other areas of the state—very close to the level in the southern Appalachians. Yet most of those in the diner this morning would agree that—work or no work, brutally cold winters included—this place and this way of life should be considered as an alternative to the perceived comforts of city living. This confusion continually tears at me and, I'm sure, at the hunters in the diner who have driven up from downcountry for the season. Our bond with this area and our sense of shared good times transfixes us as we stare into the pools of real maple syrup on our plates. The locals who are in the diner this morning, if asked, would not be so philosophical as to speak of Vermont as a "way of life," but I have heard many say that deer season is "better than Christmas."

I take a few photographs of the people at the counter, who are too sleepy to object. As the sky lightens I settle up and leave, followed by a number of hunters, their anticipation heightened by a distant gunshot. I get into my already mud-covered car and head back through Coventry, which is quiet again. I now choose the covered bridge road out to the Gool (local parlance for a circular two-mile road that leaves and returns to the village near the Congregational church) and on to the Gore. (Coventry Gore is the local name for a certain parcel of land that, although properly part of the town of Newport, had once been considered a part of Coventry as the result of an imprecise survey.)

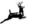

I must stop at the Liar's Club to ask directions to the next camp. The road near the Club is deep with mud and beer cans as I spin my way by the door yard to higher ground for momentum on my return. Everything around the camp in the early greenish, forest light is saturated with traces of last night's wild reunion. The beer keg sits on the stoop, surrounded by coolers. Swinging the door open, I am assailed by the stench of stale beer and cigarettes. My headache threatens to return. Loud snores from the darkness suggest no hunting

from this camp yet. Butch, the owner, who had gone home the night before, drives up, picks his way across the mud to the camp stoop, and offers me a draft from the keg. I grab my forehead. He understands, and pours one for himself. He tells me that on his way into camp he saw a deer being dragged from the woods by some out-of-staters. "I can't understand it," he continues. "We come here all fall scouting. I even drove the company truck up after work when my car was broken down. Then somebody from away comes up and gets his deer first morning. Had to be near the road too. And we pay the taxes on the land where he shot it. And the state gets the license fee! Probably driven down off the mountain by Hector or Wallace." As Butch reaches over without effort and tops off his beer, he talks of hunting these woods with his late father, and of how they built the camp together. After his father's death a number of years ago, he renovated parts of the camp. Upon its completion, he placed a sign bearing the name Coventry Gore Liar's Club with his father's name inscribed below as honorary president.

As Butch and I talk, we don't confine ourselves to hunting. We exchange some very personal accounts of family life and its difficulties. We talk about death, and life, and self-employment, and cash flow. The morning air relaxes us as the sun

catches the tops of the evergreens above the camp. Besides our conversation and the unobtrusive thwacking of a woodpecker, the only sound is the soft puff of wind though the hemlocks mixed with the creaking of the hardwoods. No rifle shots can be heard on this part of the mountain. Butch attributes this to coyotes killing fawns, the doe season, poaching, and the fact that "the lazy farts in his camp aren't out on the mountain."

After getting directions to the next camp to the west, I go back to my car to load all my gear into the pack frame. Once it is full, I struggle through the gyrations required to get it on my shoulders. Once it is secured on my unconditioned body, I venture deeper into the woods. The walk is invigorating, and with each thousand feet or so I feel myself gaining energy. Crisp air, brilliant light. The evergreens near the Liar's Club made the environment cool and dark, but as I climb onto higher ground into open hardwoods, the more direct light imbues the landscape with warmth and color as the smells of fir and cedar are replaced by those of damp, sun-warmed leaves.

As I approach Mason's camp, I am walking into a "first morning tradition" of some 20 or 30 years, not unlike the Liar's Club's tradition of moosemeat spaghetti sauce on the night before. Mason is reputed to have fresh coffee and plenty

of sausage, eggs, and beans ready for the members of the surrounding camps after their first hours in the woods every year. Although the initial hunt is often successful for those hunters who began their preliminary scouting in September, there is still plenty of time to get one's buck, so breakfast is welcome even if the deer are waiting. Any seasoned hunter knows that the first hunt is more a familiarization ceremony with your body, your rifle, and negotiating in the woods, even if you've hunted hundreds of times before. You might spend the rest of the year as a logger or a trapper, or you may be athletic, and still you may find you're not in great shape after cutting a fresh track up over two successive ridges with a weapon, a full cartridge belt, heavy wool pants, a jacket, and long winter underwear. It takes extraordinary stamina to pursue a buck on the run for hours. Breakfast this morning is as crucial as it is enjoyable. It means rest and nourishment for one's body, already a bit stiff from the day's first workout and last evening's indulgence.

I come upon Mason's camp by happenstance. Wallace warned me that for the last half mile the trail is obscured. The natural color of the camp's siding blends with the leaves and hardwoods, its outline barely distinguishable save for the bright white of the camp sign. I can see a couple of rifles

propped up next to the railing as I approach. Some people are already in for coffee. The exterior wall, upon closer inspection, has a unique metal sheathing around the windows—printing plates from the local newspaper. I unload my pack, lean it near a rifle, and knock on the door. Wallace told me I should visit this morning, but I don't know if he has told Mason about my project. I haven't seen Mason in the 30 years since he and his family moved downstreet to Newport.

The door is opened by a young woman of about 20. She turns to a fellow sitting at the table and calls him to the door. I don't recognize either of them. Do I have the wrong camp? They invite me in. I introduce myself, and then I recognize Mason. He sits in a corner, next to the cookstove, in a rocking chair. At first he doesn't recognize me, but after reintroductions we both scream with laughter as we break into "remember whens."

Mason is now in his seventies. Fifteen years ago, he explains, he moved his camp a couple of miles from its old location high on the meadow, with its view of the White Mountains and Canada, to its present location in this hardwood stand, where there is less of a view but more privacy. Even the birds are different here: pileated woodpeckers and an occasional Canadian jay. And since the camp is now below the beaver pond, he can take his grandchildren to see otters and beaver or to fish for brookies. And the new site is closer to other hunting camps. This means more visitors in November. Mason doesn't care to hunt much any more, yet he always has plenty of bunks for friends who do. This doesn't mean he won't go deep into the woods during the day. He will, and with a rifle too. But he will often, he tells me, find a warm place in the sun, out of the wind, and lean back against a tree, inhale the smells of composting leaves, and remember fall in the village, his first wife (now deceased), and his children (long since moved away). When alone he isn't lonely. He has remarried. He has his camp and his friends. Though now retired, he probably won't stay in camp for the full two weeks. He prefers the last few nights before opening day and the first morning's visits. If others in his camp want to remain for the duration he will keep them company; otherwise he will pack out Sunday night and, if the weather is reasonable, return for the remaining two weekends.

The young woman who greeted me has been coming to Mason's camp with her father for a number of years. She is now studying at the university in Burlington. Her father offers me a cup of coffee, and it warms my spirits. As they describe recent developments with hunting in this

area, we hear voices outside the camp door. Wallace knocks and enters, followed by his 12-year-old grandson, whom Wallace is proudly introducing to deer camp this year. This past summer, the boy had attended a week-long conservation camp in Hardwick; each year the men of the Liar's Club use some of their dues to help send a member's child or a foster child to this camp.

Before long there are more knocks. Coffee is offered to the new arrivals from the Liar's Club camp. Wallace asks one of them if he heard the bears talking as he walked up through the swamp, and this question brings the young people in the camp to their toes. "It's getting warmer now," Wallace says. "Bears probably won't den up for a while." A member of the Liar's Club, whom I had caught snoring earlier, responds: "Could have been noise coming from our camp. With those pickled eggs, I wouldn't guarantee anything!"

I ask if I might take a group picture. Mason grabs the frying pan, Wallace his grandson, and Mike his daughter. All assemble near the front door and the camp sign. This group is easier to gather than the thirty—in various stages of inebriation—I photographed at the Club last evening. Butch had called them to order by unbuckling his .44 magnum pistol and pointing it toward the ceiling with the hammer cocked. After I take a few portraits, the hunters leave, walking through the hardwoods in single file and then spreading out diagonally to begin their sweep of the swamps below Kidder Pond.

Mason is washing dishes in the dry sink. I walk over to shake his hand, preparing to take my leave. Mason walks out with me and helps me adjust the pack onto my shoulders. Although the temperature is comfortable (maybe 40 degrees), I decide to wear my red wool jacket for self-preservation. As I walk out to the car, I realize I must pace my late-night research in order to maintain energy for the next 14 days.

Having gotten my first taste of hunting Orleans County style, I decide to drive to the heart of the Northeast Kingdom: Essex County. I will visit a merchant with whom I spoke briefly last week while scouting. This fellow's market is both a convenience store and a deer checkpoint for many of the outlying areas of Brighton, Ferdinand, Averys Gore and Warrens Gore, Lewis, East Haven, Morgan, the Charlestons, and Newark. These towns and townships (unchartered) comprise more than 200 square miles, much of the land being owned by paper companies. Unsettled

with the exceptions of hunting camps and a few year-round homes, most of this land is used for hunting and fishing.

Island Pond has its usual periodic traffic for a Saturday afternoon: logging trucks, empty and loaded, booming down the main drag; pickups so covered with mud that the rust doesn't show; regulars convening at the Hotel Osborne; and visitors stopping at the Common Sense, a restaurant owned and operated by members of a communal sect called the Northeast Kingdom Community Church. By the time I arrive at the checkpoint, pickups are backing in to unload deer for weighing. While the Fish and Wildlife biologist pulls one tooth from each animal to determine its age, the hunters strut into the store to inspect the list of deer already weighed. They also ask about numbers of points and where the various deer were shot.

After the proprietor of the market takes a snapshot of each hunter with his deer, the image joins a growing exhibit of visual records in the front window. When I ask the store owner if many of the hunters in the snapshots are hunting out of camps, his body language suggests that this is an absurd question. After a pause, he asks "You from the area?" "I'm from civilization," I retort. "Coventry!" We both laugh, and he begins to address my question. Many of the names on his buck register are affiliated with camps. He mentions a few, none of which I recognize. As he looks to the biologist for help in jogging his memory, they come up with the names Mad Dog, Barre Hunting Club, Hardwick Camp, Neverhomeboys Lodge, Loon Camp, Circle-B, Big Moose Camp, Crooked Spike, Paradise, Gore Camp 10 and Gore Camp 12, Whiskey Brook Camp, What's Cookin' Camp, Cordwood Camp, Lyndonville Boys, Lost Nation Camp, North Ferdinand Lodge, the Bull Mountain Boys, The Summit, the Tim Carroll Camp, Camp Frying Pan, and Fort-Hort Resort. As they list these humorous and romantic names, the proprietor mutters directions: "Three miles in on the Henshaw, or turn left near the second bridge off the North Branch." "Continue by 'Short Trout's,' but you can't see their camp from the road anyway. . . . Park your car well into the ditch, if you decide to look for it, so a logging truck barrel-assing down from Lewis doesn't take your car with it!" Quickly jotting down locations and names, I describe my plan to document deer hunting and the camps, and we talk about what hunting means to people in Island Pond and to the economy of Essex County.

I picked raspberries and blueberries between Island Pond and the New Hampshire border during

mid-August two years ago. Although I noticed occasional small houses and camps along the highway, many were boarded up and seemed to have been abandoned long ago. Now, driving east on Route 105, I am amazed to find that most of these places are very much alive with what I assume must be deer-season-related activity. Even the smallest shack has three or four pickups or campers around it. Smoke can be seen rising from the chimneys, and the dim light of gas lamps and lanterns illuminates the windows.

While I was photographing at the checkpoint, a group of hunters had invited me to stop by the Mad Dog camp. It is not easy to find, as there are many "small cabins on the left with vehicles in front and coolers on the stoop." Only after turning around and driving back toward Island Pond do I spot the "Mad Dog" sign and the canine jaws painted on a rock outcropping. I am not accustomed to driving up onto front lawns, no matter how modest, yet here are trucks parked randomly about. I careen up over the bank and land somewhere near the front steps.

My noisy arrival brings a few of the sons around the corner of the camp, fortunately followed by their father, whom I have met in town. I am introduced and invited to the picnic table out back. The back yard (only 30 by 30 feet) almost

has the feeling of a shrine. It is bordered on one side by the camp and on the other side by an old, green-painted Airstream trailer. At the center of the pine-needle-covered lawn is a picnic table with two or three cases of chilling Budweiser stacked on a bench. The deer I had photographed earlier in town hangs from a pole. Hunters are celebrating at the table. Though it seems cold as hell to me, some of the men's beards are wet with perspiration; they have just come from the woods. I am given a beer as I reach to shake hands with one of the camp members. Before I empty the first can, another is thrust toward me. I have to put it down to retrieve my camera and flash so I can oblige the hunters' request that I take a group portrait. The light level is dropping quickly, so I ask the camp boss to gather everybody right away. (Darkness and alcohol will often hinder my photography on this project. Fortunately, my earlier scouting has put me in touch with many hunters and families who do not drink at all or who forbid alcohol around their hunting camp.)

I take the picture and get a quick tour of the Mad Dog camp. Entering a hunting camp after being in the cold for 5 hours is an extraordinary sensory experience. The heat of the woodstove fogs my glasses, reducing the interior to a blur. Dinner simmers on the cookstove, soup or a stew.

A mustiness from the long period during which the camp was closed lingers for the first few days of the season until the dry wood heat and the occasional backpuff of wood smoke lends all the rooms an inviting pungency. The owner of this camp leads me into one of the bunk rooms and pulls down a movie screen, which is permanently attached to the ceiling. "Skin flicks" are a part of the merriment of the first few days at this camp, as at some of the others. He maintains that most of the drinking and the viewing of flicks takes place on the first weekend of the season, after which the hunters get down to business and "hunt hard," rising early and staying in the woods all day.

It is now past 5 P.M. and pitch dark. I have decided to try to find the Bear's Paw, so I thank everybody at Mad Dog for the beer and tell them I'll be back next year with a photograph for the camp. Turning on my headlights, I see snowflakes. Pulling onto Route 105, I encounter many pickups heading into Island Pond. I decide to continue toward East Bloomfield to stop briefly at a camp that was suggested by a woman at the checkpoint. Finding it in the dark is easy, as I have been told to look for a 55-gallon barrel with a pair of boots sticking out of it, suggesting a body has been thrust head first into the barrel. This camp

driveway, like the last one, is full of vehicles. I continue up the road, turn around at the railroad crossing, and decide to return and find a place to park.

There must be fifteen trucks, cars, and vans parked all over—between trees, on the side of the road, even down in the ditch. I sit in my car planning what I will say when the door opens. A woman at the checkpoint had said that these guys were "really nice" but had asked me not to mention her name; the latter added a curious implication to the gathering of males inside. What the hell. No real introduction, no name to use. With trepidation, I stumble through the darkness to the entrance. I knock on the door, wondering if I'm violating protocol. No answer. I knock harder, and a chorus of angry-sounding voices requests my entry.

I open the door. As my glasses fog up, about thirty rowdy characters fade from focus. I recognize nobody. One guy has a double-bitted axe in one hand and a bottle of liquor in the other. Rifles hang on racks near a side door. Thanks to a woodstove that must have been the largest and most elaborate available from Sears, Roebuck at the turn of the century, most of the men are in T-shirts. Some are cutting vegetables into cauldrons simmering on the stove's back burners. Be-

yond the stove and the illumination of the gas lamps, I see others moving amid stacks of bunk beds in the darkness. My first impression is that of hair; most of the faces are obscured by heavy, untrimmed beards.

I have to rethink my first words. A man who appears older than the rest, seated at the head of the long dining table, asks sharply "Can we help you?" As I blather something about my interest in deer hunting, I keep an eye on the fellow with the axe. The men have quieted down. I rivet their attention—for the wrong reasons, I'm afraid. They stare as they wait for me to get to the point. I'm thankful for a few questions from some of the group who aren't from Island Pond. The natives remain silent and continue to scowl. I apologize for just stopping in, something that is done only by friends from other camps or from Island Pond. Finally, the heavily bearded fellow who appears to be the camp's don orders one of the younger members to "get the man a beer, goddammit!" Some of the men slide down the bench to allow me a seat at the table. The don offers me a slice of pickled deer heart. I have no idea what I am about to eat, how it will taste, or if this is the first of a number of jokes to be played on a newcomer. I nonchalantly take a bite (it tastes like fine beef tenderloin) and wash it down with a swig of beer.

I garner a little respect when I ask for directions to the Bear's Paw, which I hope to visit in the next few days. The camp boss now hands me a slice of tongue on a fork, and some of the others proceed to draw me a map and offer verbal directions. I am warned, jokingly, about a hunter at the Bear's Paw who tracks deer like an animal: "Christ, Sammy can smell deer in Ferdinand if he's in Wenlock. I've even known him to track a buck on a dead run across dry leaves!" As I open the door to depart, two snow-covered hunters barge in, yelling "Who's going to Bear Mountain?"

It is now 6:30 P.M. As I drive along down the highway past the logging road that leads to the Bear's Paw, my car tracks softly through a carpet of new snow. It is now 24 hours since I crossed the threshold of the Liar's Club to begin my journey through time, suspended from everyday life.

Why do men go to such great efforts to build a hunting camp instead of merely hunting from their homes? When I was growing up in Coventry, in the 1950s, most of the kids in town had "camps." A camp was any place away from one's house and one's parents; the distance did not have to be great. My first camp was in a stand of maples

behind my family's home, on adjoining property. I started going there, often with my older friend Phil, when I was 9 and Phil 11. The camp was on high ground, and we spent hours there watching what was happening down in the village—especially in the fall, when the view was not blocked by maple leaves and when we were not busy fishing and playing baseball.

By the time I was 11, other friends had built a better camp. This camp was a crude treehouse nestled within a grove of white pines. Its elevation, 15 feet above the pine needle floor, gave the treehouse an ethereal magic. It was here that I shared in certain common experiences of adolescent boys: smoking cigarettes, perusing girlie magazines, displaying and comparing our biceps and genitals.

This youthful desire to go into the woods and build a camp away from one's home, to pass secrets and share intimately with one's friends while enjoying the changes of the seasons, must have been carried from childhood by some of these hunters. Returning annually has become a ritual, a recreation of their childhood memories and experiences. I am here for similar reasons: to enjoy companionship in a place and time removed from the everyday, repetitive monotony of home, with its responsibilities and stress. To be a child again, curious, open, frightened, and in good physical condition. I have yet to achieve the latter.

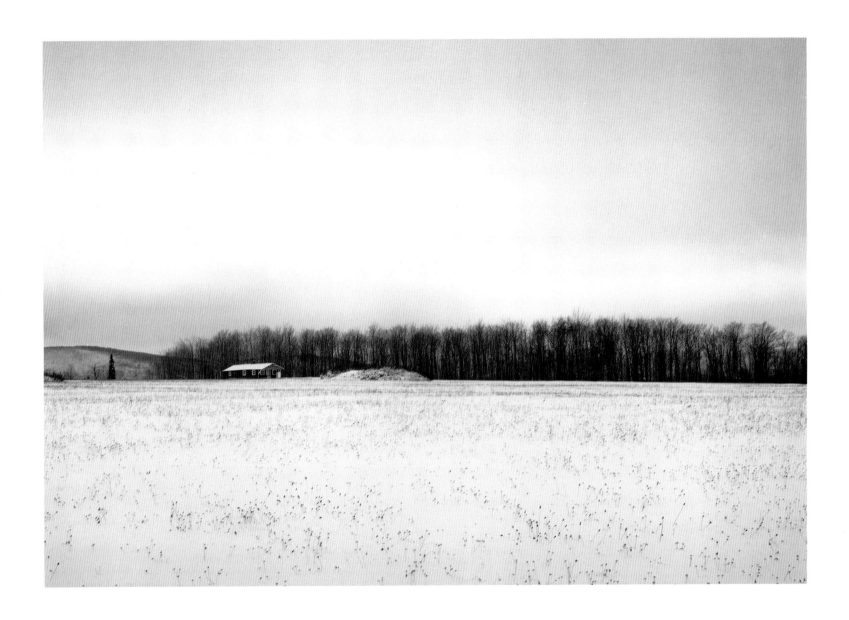

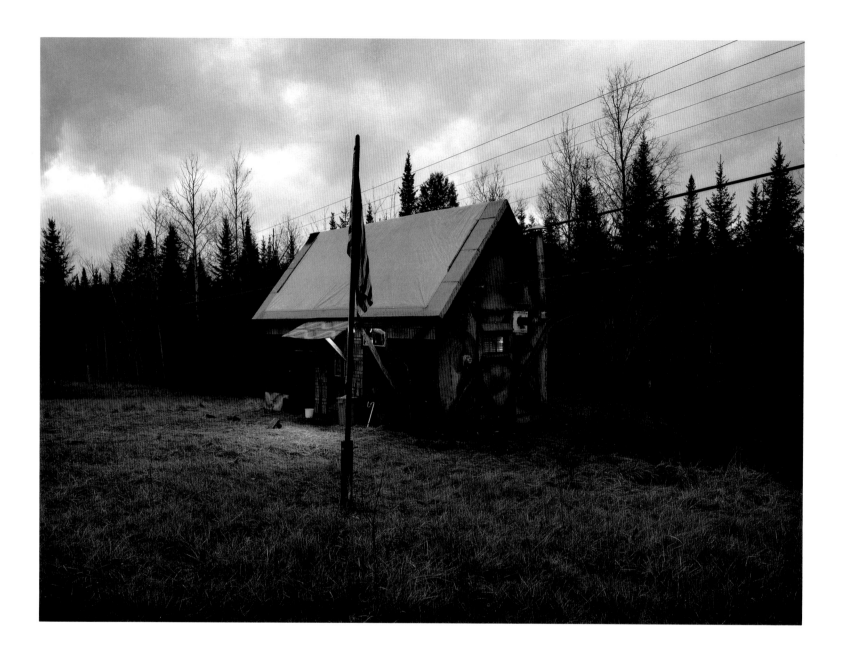

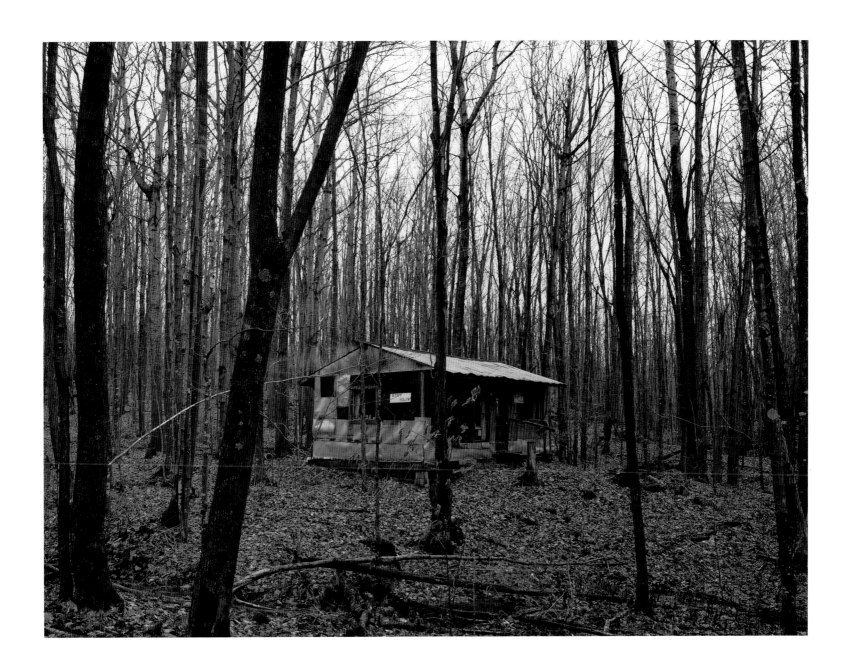

All the camps that are in this Northeast King-dom . . . take all these camps and all the men that are in them. . . . What share of them are actually hunting hunters? The biggest share of them are non-hunting hunters like us that enjoy getting out of that normal rat-race routine that we're wired into, the system. And come to camp and maybe they don't even cook at home, or make their bunk or sweep the floor. . . . They come here and they love it. Because it's a change, or cookin' the meals, splittin' wood. It gets you away from that, it's a different environ-ment. It's a vacation. You don't have to answer the phone; we don't have no phones here. We lug our water. We got gas lights, that's about the most mod-ern thing we got. We don't even have a radio in camp. Nothin'. We don't want to know what the outside world is doing, really. We come here, and it's quiet, most of the time, except for the riffraff that rolls in off the blacktop there, lookin' for a free meal or somethin'.

—cabinetmaker

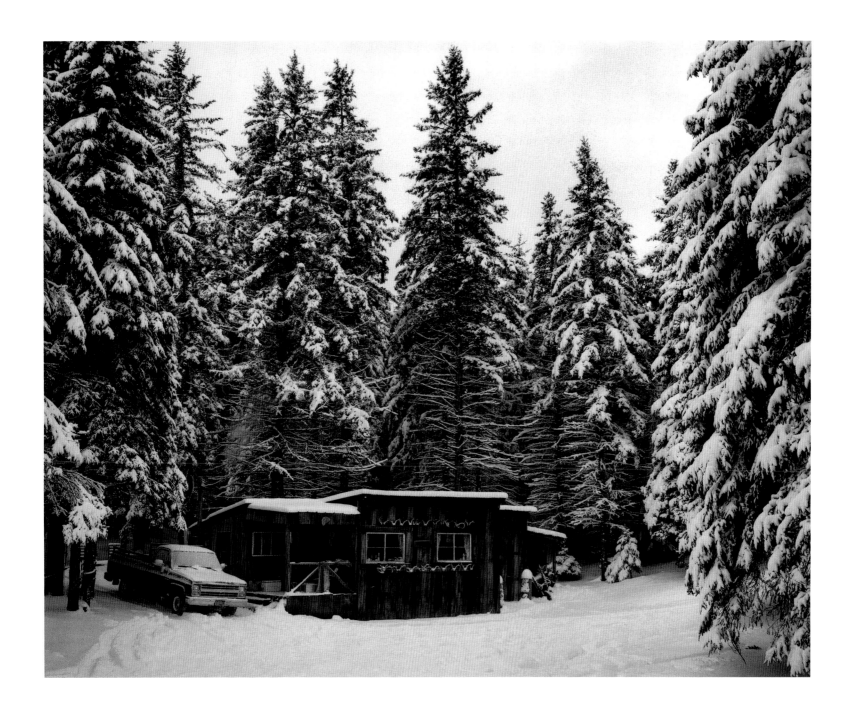

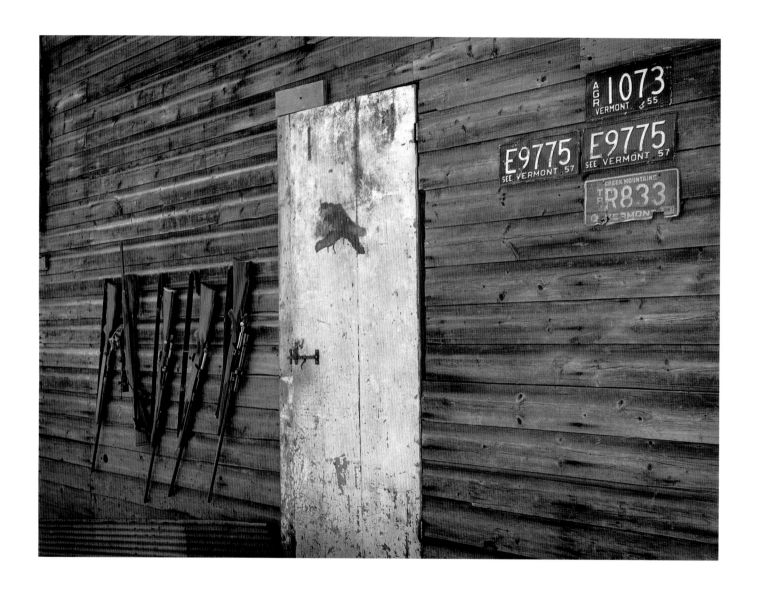

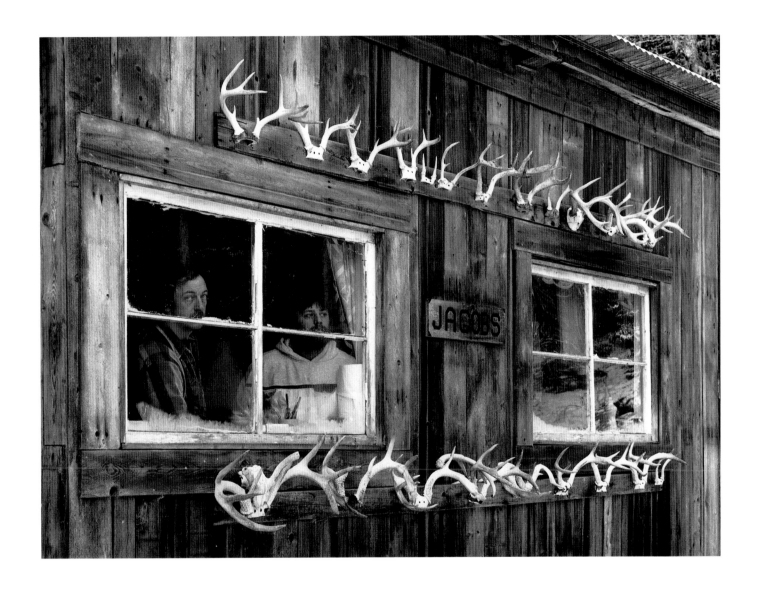

27

That's my lucky britches. But they didn't bring me no luck this year. . . . Oh, you got your lucky pants and your lucky shirt and your lucky shoes and lucky this and lucky that and you're lucky if you get a deer!

—railroad maintenance worker

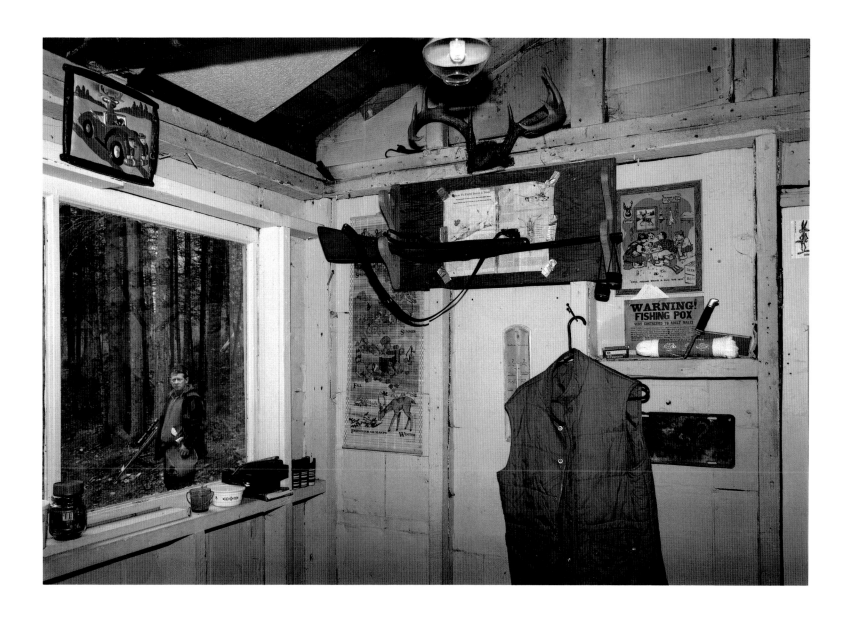

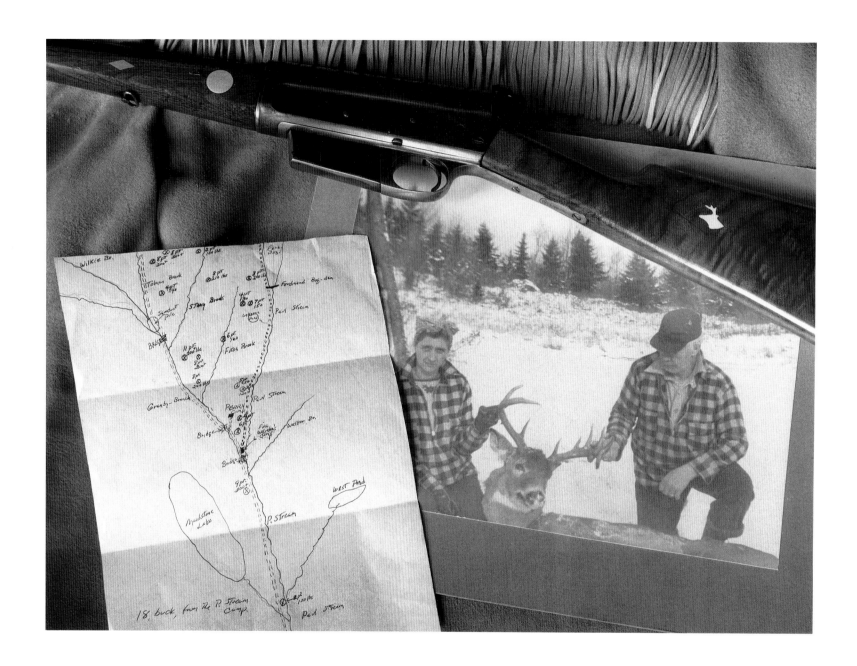

Well, the first time that I came to deer camp for deer season, I was 12 years old. [My father] took me out of school and brought me up here. Mr. man, if that wasn't something. Boy. Ten men in here, ten great big men, rough, gruff voices. He'd back the pickup truck up there and they'd take out the cases of beer. Whole pickup truck load, and they'd stack it in there where that wood is stacked, right to the ceiling, case after case, forty cases or so.

I'd just come up for maybe a weekend or somethin' like that. Maybe Friday, I'd take Friday off and Saturday and Sunday and I'd be back home for school Monday. Man I was in the dishpan, I lugged the wood, split, kept the friggin' place swept up. I did everything. I'd get all done and after supper, I'd get the hell out of the way and they'd do dishes and have a few after-dinner drinks, gettin' ready to get the table ready for the poker game. I'd go up on that bunk right there, and lay there with my arms folded, my pillow there, and I'd fall asleep watchin'. Smoke, they'd be cussin' and raisin' hell.

Ya, it was very exciting. And I felt very privileged to be able to be here. Because I was the only one back then that had a father that would bring their kid into camp. I don't know, I'm sure dad got an okay before he did that. How well that ever set with anybody I don't know. But he wanted me there.

—woodworker

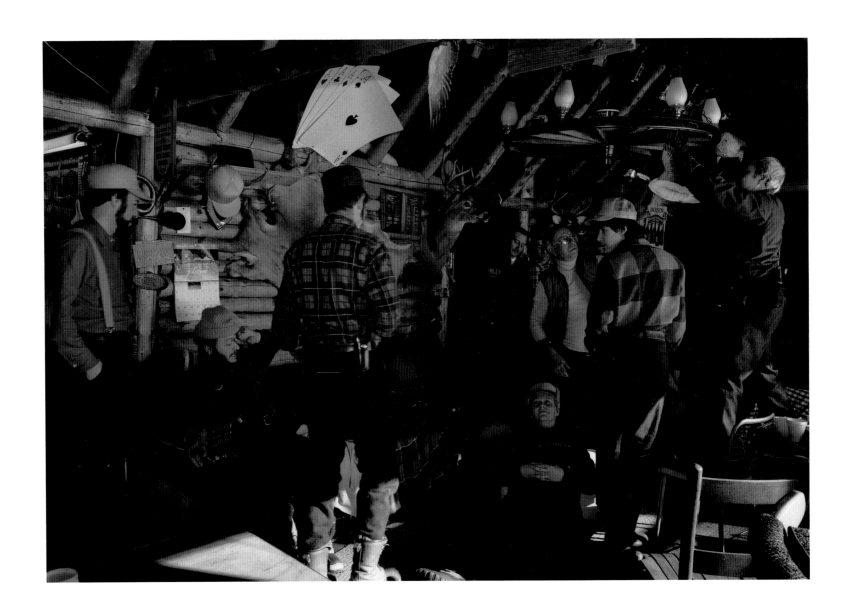

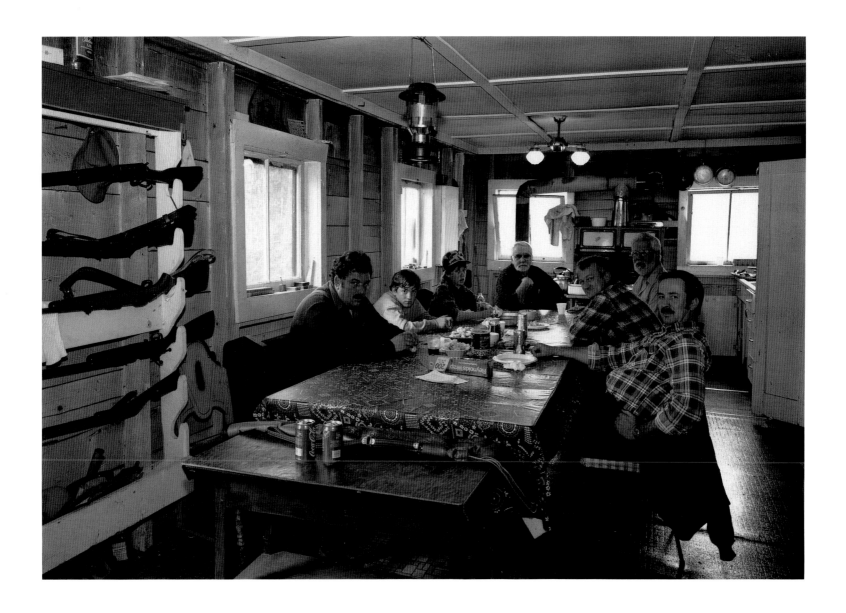

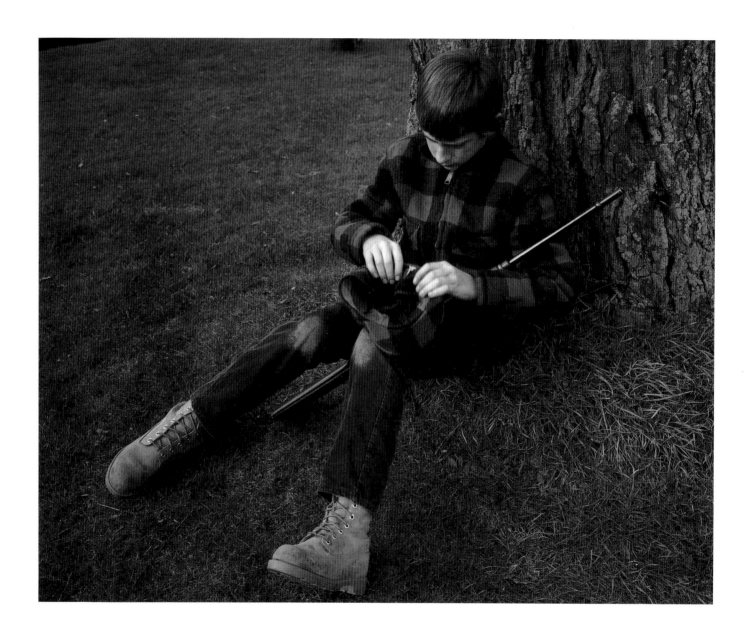

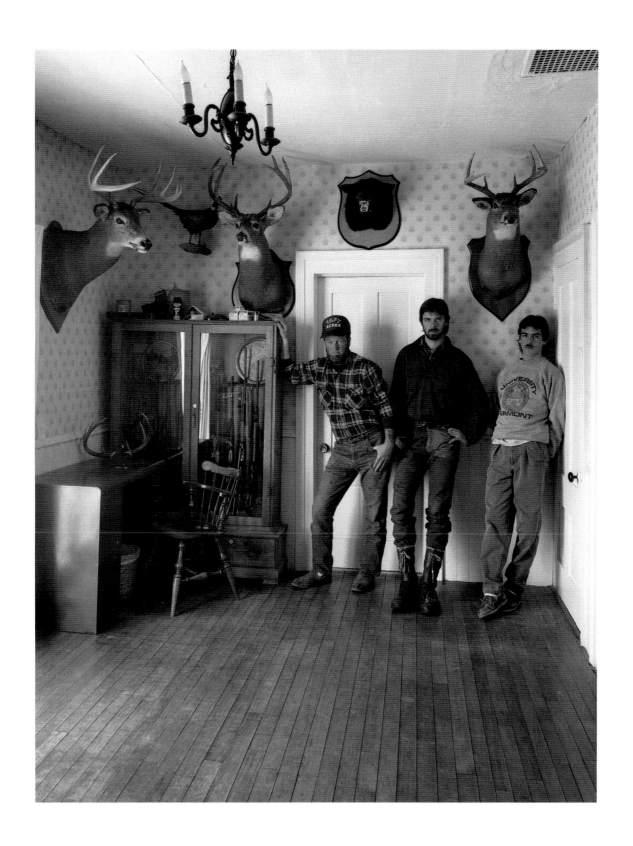

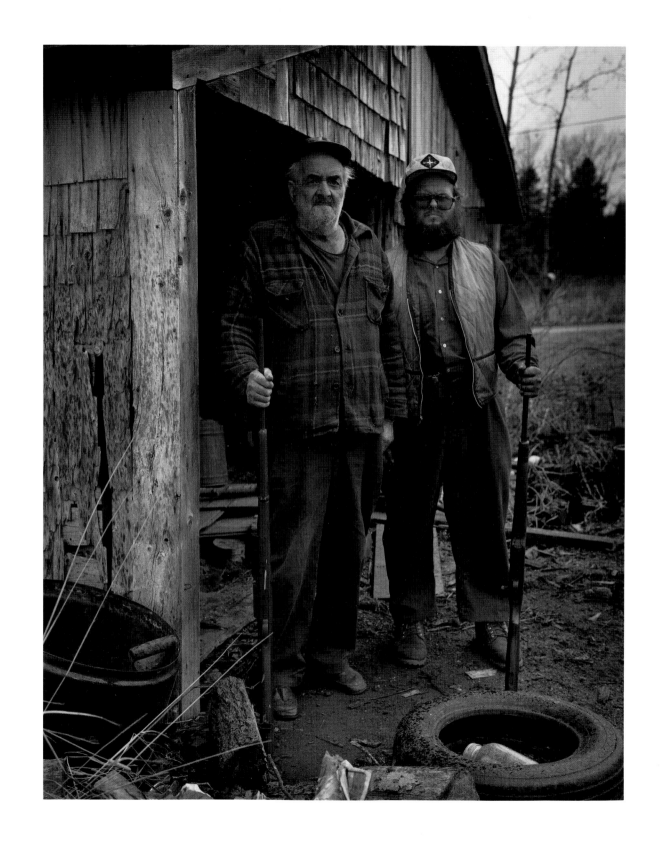

The biggest deer that [my father] ever got was 310 pounds. . . . That was a sixteen-pointer. That's set up. And dad gave that to me. That was shot the year I was born, 1921. When I got married he gave the head to me.

And then my dad had a stroke, he couldn't hunt. I drove my deer, a ten-pointer, up where dad could look out the window and see that deer. Of course Dad hadn't seen a deer until we drove in. He said "Any luck today boys?" I says "Ya, I says I got a goddam calf." "By Jesus, one of these days," he says, "you're gonna get caught shootin' them goddam small deer!" I says "Well look out the window, Dad." He looked out and the tears come into his eyes. He was so happy.

—carpenter

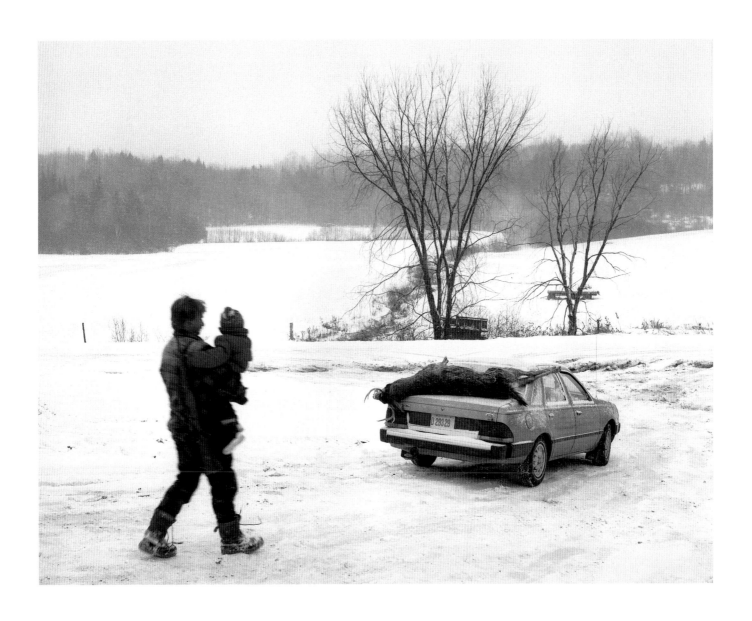

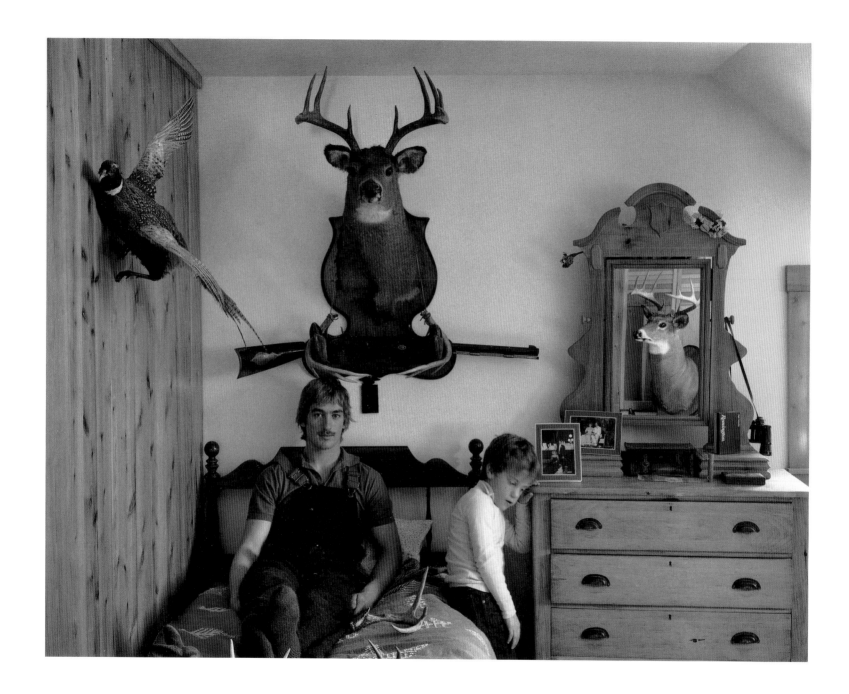

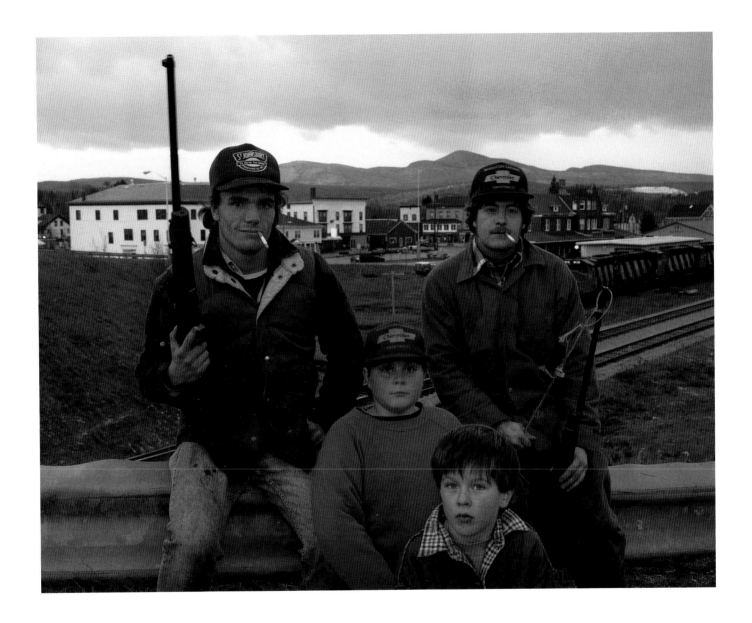

Driving north this evening, I find Lyndonville quiet and cold. I look forward to visiting the Bull Mountain camp. I have been invited to come over middle weekend, when most of the Haven brothers will be in camp. I find the trail off the main road thanks to another well-drawn map by a woodsman. This road, like many of the other camp roads I have seen, is a narrow, circuitous corridor of darkness through snow-covered evergreens, which scrape against my doors as I pass through to the opening beyond. Tonight only the warm glow of gas lamps can be seen in the windows as I pull into the parking lot. There are only two hunters here tonight: Russ and Keith Haven. Most of the hunters have gone home for the evening to shower and to get provisions for the second week of hunting.

Russ offers me a cup of coffee and begins to relate the day's hunt. He backs it up with an overview of the past week. Most of the six Haven brothers and their sons had been in camp, and they had been working one area hard in an attempt to learn the movement patterns of two or three "good" deer, in the 250-pound range. "Nice rack," he says, forming a circle with his hands. "Mountain buck." He explains the difference between such bucks and the smaller ones that stay at lower altitudes, in fields or swamps. They are totally different creatures, according to the hunters. The lowland buck is often filled out through its entire body length, and its antlers grow out and up. Since it feeds on field grasses or the more digestible vegetation closer to wet areas, the venison will probably taste milder and will be more tender. The mountain buck, more indigenous to this area, has a skinny ass and massive shoulders. Its weight and strength are concentrated right behind the rack—important for its upcoming battles with other bucks during mating season. Constant running through heavy undergrowth (or "dirty" areas, as some hunters say) has caused an almost evolutionary change in antler growth, such that the mountain buck's tines will grow almost in a full circle, coming close together at the top. Russ explains that he knows the type and size of a buck from the tine impressions it leaves in the snow when feeding or (more likely) searching for a doe in estrus. He reminds me that this kind of knowledge can only come with repeated observation of many deer from a diversity of habitats.

Much earlier today, David—the brother reputed to be one of the best hunters and the master planner—roused everybody an hour earlier than usual, proclaiming "We're going to take one of the bucks off that mountain." His enthusiasm catapulted the younger men from their bunks into

the startling cold of the camp interior. One of the older hunters, who would hang low as a point man, made a light breakfast. David left the others sitting at the table and went out to start the pickups, with a piece of venison in one hand and his rifle in the other. On his return, he saw that the early rising had left some of the members bleary-eyed. Nonetheless, they were all in their trucks as planned and up on the logging roads before anybody else. "No wheel tracks! A good sign," said Russ. "Means we've got the jump on anybody else." A few hunters "from downcountry" had been working the fringes of the Havens' territory closer to the road and had surmised that the natives were after something big. They'd probably seen some of the tracks or heard one of the locals say "We're on a big track" over an open CB channel. (Some hunters change the orientations of the crystals in their radios to create private channels.)

Somebody in Russ's group got the first call, around 7 A.M. It was still dusky on the lee side of the mountain, but higher up there was more light. David had seen the deer first; when he jumped the deer from its bed he had caught a glimpse of its bolting form in the gray light as it blended into the hardwoods and whips out ahead. The twitching white of its tail had caught his attention. David's partner Keith, with a vantage point more broad-

side and a hundred yards away, had seen the rack. He cut up diagonally, moving carefully, to corroborate its size with David. They agreed that this was a mountain buck. And the size of the tracks gave an indication of its immensity. David got on the radio and quietly called the two other parties, who were far out ahead.

When Russ's group got the call from David, the adrenaline started to flow. The creator of the tracks they'd been seeing all week had finally been jumped. David relayed new instructions. One of the men would stay put for at least 2 hours. He and his partner would cut down and traverse the base of the mountain, keeping a quarter mile or so between them. He'd cut northeast while his buddy worked to the south. After an agreed-upon length of time, both would move slowly and straight up. If the buck was a quarter to a half mile ahead, he wouldn't start to travel too fast if the hunters moved cautiously. The wind had not picked up, nor had the temperature, so for now they wouldn't have to worry about their scent traveling up to the buck. When it did, and it would, the buck would head for the high country and into the territory of the Lost Nation hunting camp at the summit.

David moved forward quietly. After climbing what seemed to be rods instead of feet he stopped

to scan the grays and browns up through the forest, trying to differentiate any peculiarities of form. He wasn't looking for a deer now. Rather, his acutely focused vision searched for a horizontal line among the verticals scribed by trees and saplings. The blackness of an eye against the middle grays. A branch, coming to a point, without twigs, and with curves instead of linearity. Another 50 feet. Gaze. Then 100 feet. Gaze. The light level was bright enough now so the colors of the landscape and the green in his jacket looked normal. He couldn't look long at his jacket, though, for as he turned his eyesight back to where he was headed everything had a momentary reddish cast. Maybe too much liquor last night.

After a while, David radioed members of the Lost Nation camp on Seneca Mountain above to relay the sighting and to advise them to spread out. As he spoke, something moved off to his side. He froze. The voice of the other hunter kept on crackling over the radio. David felt his pupils dilate. He couldn't turn his head directly, nor could he turn off his radio, without moving. He held the radio and the rifle in the same position for, it seemed, 5 minutes. Both hands began to cramp. Keeping his head still, he very slowly moved his eyes. He knew the buck was watching him. If he even moved his eyes too quickly, the

animal would whirl and be gone. The voice on the radio became quieter and stopped. David hoped his friend knew the reason for his silence.

After scanning a sufficient distance, he allowed his hand to rest with the radio at his side. He turned slowly to face the area where he had sensed movement. No deer. He closed his eyes and listened. He waited another 5 minutes and walked toward the stand of trees near the perceived movement, five steps at a time, until he reached the area and looked at the ground. He hadn't been dreaming. There were the fresh tracks. Nearby the snow had been urinated upon and showed fresh scrapings of the sort that a buck makes when marking his territory.

David called Russ first, determined his location, and told him to start moving up, keeping his hunting companion close enough so the buck wouldn't come down. Although the order was put out to the hunters above to start tightening, they still had a few hours of hard going through deadfall and slash left by loggers.

It was now about 10:00. David and Russ had probably moved a mile, while the others continued closing in. One major problem haunted David: a weak spot through one steep area of ravines offered an easy escape route for the deer. The air was still so quiet that David could hear his heart

pounding from the excitement. As he eased his radio back into his coat, BOOM! He stiffened and looked in the direction from which the sound had come. He waited. No sound or movement, other than a flock of crows disrupted by the blast.

He shouldered his rifle and started walking. As he came through one tangle he saw the green coat of his brother Eric. Eric was excited. His face was white. David knew he'd shot at something. They walked over to the area where the deer had last been seen to look for signs of hair or blood. A circular slew of clean, white tracks spun out of the opening and to the south. The fact that the incoming track had come from David's position suggested that they were on the same buck.

Nothing was mentioned of the miss. As David turned on his radio, one of the hunters at a higher altitude broke in to ask the location of the shot. David had to make the decision which way to direct them. He said to hold off for 15 minutes while he and his partner walked out the track a ways to see if the deer had maintained the same general bearing. They moved out quickly through the hardwoods. The softening snow made the track easy to follow, but David knew it could never be this easy for long. Within another 50 yards his intuition proved correct. They crossed more sets of tracks leading off in diagonals, with one smaller set—maybe a doe. "If the buck's in full rut his head's going to be down sniffing that trail, neck swollen like you wouldn't believe," says Russ. "He's after one thing. Then they act stupid!"

Within 45 minutes, David had come down to Russ and his partner. After quickly recounting the previous few hours, Russ posted his partner and joined David. Once through another stand of evergreen they came upon their older brother Murphy and his 10-year-old grandson Will, who was in the woods with a rifle for the first time. Russ and David told about the buck, using the word "monster" instead of their more common "nice" for the benefit of the 10-year-old. "His eyes got as big as saucers," Russ laughed. As they took a break to eat sandwiches and an apple, David took care to make the younger hunter feel part of the team, telling Murphy and the boy to move slowly behind him and Russ.

As they began to run, they kept cutting slowly away from the remembered direction of the tracks to keep enough distance between themselves and the deer in order that their noise wouldn't cause alarm. Their body odor might scare the doe, but it probably wouldn't distract the buck from his higher priority. "We didn't know how far ahead that buck was," Russ says, "but we had at least

two, two and a half good hunting hours left. By four, if you don't have a wounded deer or a dead one, you better think about taking a compass reading and heading back for camp."

Russ stopped to light up a cigarette. Russ was older yet leaner than David, and you could read the Abenaki blood in his features more clearly. The younger brother was in better physical condition, being a weight lifter and a soccer and hockey player. (The local leagues had "farm teams" made up mostly of men who worked in the woods or held other physically demanding jobs; they often won through sheer strength rather than through skill.) The older brother was more familiar with the woods. They would run below the track another hour and then begin to cut up toward it. David would go straight and Russ would cut slightly north of east in a subtle backtrack. It had taken Russ and David a week to "get their legs back" after not using many of the muscles required for this kind of strenuous activity for a year.

The sun was now warming the mountainside, and the snow was slowly shrinking. David and Russ, with their coats unbuttoned, their wool shirts open, and their heavy beards dripping perspiration, were now running straight uphill. Just as David, who was in the lead, stopped to catch his breath, a rifle shot broke the silence. It sounded close. "Down in the ravine in front of us," says Russ.

Within minutes they heard a godawful crash near them and to the north, then the pounding of feet and another crash. For a split second, across and downrange from them, the buck leapt ("like a freakin' photograph in one of those hunting magazines," says Russ) and was gone. He looked to be going down to the low areas beyond the ravine. Neither Russ nor David could remember if the buck had his tail down, indicating that he had been wounded; yet the fact that he was going downhill suggested that either he had been hurt or he was "all screwed up from those does."

According to Russ, he and David started covering ground down the mountain "faster than Christ flew over the treetops." David slipped and dropped his radio as he tried to jump over a fallen birch tree. David decided they had better stop, try the radio, and call in some support. Murphy and Will, who were down toward where the buck was running, didn't have a radio. David radioed the group they had left to the north and told them to "beat it west toward the swamps to cut the sonofabitch off before he gets out onto some of the islands."

He and Russ then checked the tracks. There

was no blood, but they could tell that the deer had an injured leg by the fact that only three distinct prints appeared with each bound. The fourth was erratic, suggesting a broken leg. Around 3:00 or 3:30—after taking the track for 15 minutes—Russ noticed spots of blood where the injured append-age should have left a fourth impression. The hunters were still in the golden glow of late after-noon light, yet they knew that as they descended into the evergreens and the deadfall the sun would be lost to shade and, before long, dusk. "You have a half hour of extra hunting time if you work the top of the mountain," said Russ, "but you wouldn't want to walk out through three miles of these bogs in the dark!"

David and Russ decided to split out diagonally from one another, away from the track, at enough of an angle to increase their chances of controlling the deer's movement. If the buck cut abruptly off in either direction, one of the hunters would con-nect with the new track. Murphy had heard the one shot but knew that it had not taken the buck down; if it had, the kill would have been an-nounced with the customary signal of shots. He and the boy had moved in closer to some of the swamp areas, where the late-afternoon light would be relatively good. The boy had been in the woods many times, so his grandfather posted

him against an old cedar stump near a beaver pond. The boy was told to keep looking through the natural corridors between the cedars and tama-racks, with his rifle ready, until his grandfather returned in 30 or 45 minutes. He was assured they'd be only 200 or 300 yards apart.

As Murphy quickly vanished in the maze of conifers, the boy searched the openings between the trees. He could feel the cold now. His new wool hunting pants were itchy, and his toes had not been warm all day. He and his grandfather had had to stand around in one place most of the day instead of hunting. Maybe this was the way he was supposed to start the first season anyway, he thought. Being alone seemed to make his hands colder. He considered releasing his rifle's safety, to be ready in case anything should happen. He pulled down his cap so that the visor cut out most of the brilliant reddening sky, and his pupils opened enough to allow him to see deeper into the darkness of the foreground. He snapped up the rifle to set his bead on the black form of an abandoned bird's nest in a distant branch, just to make sure he remembered the technique. He re-peated this a few times until the bead naturally fell on the backlit form; then he decided to nestle against the cedar.

Just as the boy was adjusting his rump to fit

comfortably between the exposed roots, a crash and then a periodic thumping came through the woods behind him. He wheeled around quickly enough to see the feet of a deer as they plowed through the snow behind him. He only caught this flash of movement through the strip of vision between the ground and the bottom of the branches. He dropped to his belly to see better. As the deer hit the water it cut left, skirting south along the pond. This all happened so quickly that the boy wasn't able to turn back to see the deer as it passed before the clearing, obliterating his view of the bird's nest and the trees beyond. He only heard two or three splashes and thought he felt the deer's shadow as it rocketed away.

He was supposed to stay put, but "buck fever" was now upon him. Where his grandfather was, or his uncles, or the locations of the quagmires he'd been warned about, were concerns now blurred by the intoxicating power of adrenalin. He moved through and around the trees as in a dream, as if his feet never touched the ground but his corporeal self was being transported across a landscape without trees toward, not a deer, but something of magnificence and beauty which pulled him toward it. It was more a force than the animate form of a deer. It was dark and frightening, yet alluring and magical.

David had slowed to a walk as he continued west. He stiffened as he heard the crashing again, now at more of a distance and in front of him. It couldn't be Russ making that kind of noise. He shed his coat and radio, stuffed some shells into his pockets, and ran toward the source of the sound, which had by now subsided. Within minutes he broke into the opening near the beaver pond to find the three-footed track leading down and across the dam just below him. The coolness of mountain water flowing through and beneath the tangle of interwoven tree trunks and brush had apparently preserved the snow on top of the tangle to reveal the buck's tracks. The dam was 100 feet across.

David looked for the first stable footing on the slippery dam. The deer's feet had gone into the dam slightly, but its forward momentum never allowed the concentration of weight. As David stepped onto the dam, he looked up at the deep black water above. He had to keep moving cautiously but quickly to keep on the deer. He stood up from his crouching position to take much larger steps forward.

As he approached the middle, his nephew came running along the shore behind him and yelled "Uncle David!" As he turned to silence the boy, his shifting weight made him step too close to the upper edge of the dam. He splashed into the water, throwing his rifle back toward the edge of

the dam to keep it from going in with him. He remembers seeing the rifle flying through the air.

As David's head went beneath the surface, he heard the gun fire as it hit the dam. He flailed his arms to get back above water. His clothing and heavy boots restricted his ability to paddle. His arms and legs moved in slow motion. In the frigid darkness he began grappling for one of the branches woven into the dam. He wasn't sure in which direction to move—and if he went the wrong way he'd be dead. His movement was slowing. Suddenly he felt his feet hit bottom, and he thrust himself upward, grappling for the dam and finally erupting through the 6 inches of floating brush and brackish matter at the water's surface.

Pulling himself up onto the dam, David saw that his screaming and sobbing nephew was unharmed. The boy was too shaken to tell David what had just occurred. But after Murphy arrived and David was safe on the bank, the boy started screaming "I got it, I got it! I shot the deer!" Murphy turned toward the boy and then toward David. David, in partial shock from the exposure, shrugged his shoulders. "Over there!" the boy screamed. "On the other side!"

Murphy, who had been comforting his grandson, stood up, looked into the darkness of the cover on the other side of the pond, and asked "Where is he, son?" The boy stood up on shaking legs. Holding onto his own rifle and his uncle's, which he had picked up from the pond's edge, he pointed toward what seemed to be brush covered with snow. As Murphy and David strained to differentiate the deer from the background, they heard the voices of other members of the family coming through the trees. As Russ came into the clearing from the darkness of the woods, Murphy told him to look over on the other side of the pond.

There, indeed, was the downed buck. "Mister man!" said Russ to the boy. "Who shot it?" "He says he did," reported Murphy, referring to his grandson. "He must have," said David shaking his head.

As the others arrived, everybody began shaking the boy's hand. Murphy put his arm around his grandson proudly, if for only a moment. "Do you remember the signal?" Murphy asked. The boy levered a round into his Winchester for the first shot. One shot, a long pause, and then two more shots in quick succession was this family's way of announcing success. They heard answering shots to the east, followed by whooping and yelling. Before long, more hunters arrived to hear the boy's story.

It must have been David's splash, according to the boy, that had spooked the deer out into the

open along the edge of the pond. "I pulled up and BANG!" he gestured. "He dropped right there," the boy said proudly, looking at the other hunters. Two of the men were now secretly chagrined at their failure to mortally wound the deer much higher on the mountain.

Murphy told two of the younger hunters to get David on his feet and moving to improve the circulation in his legs. As they followed his orders, Murphy, Russ, and the boy walked up toward the head of the pond to a point where an easy crossing enabled them to return south along the opposite bank to look for the deer. The dusk seemed like night as they struggled through cedar thickets so dense that they had to walk backwards to protect their faces, their jackets, and their rifles.

The boy yelled for joy as he ran toward the buck lying in the snow. Russ admonished him strongly. "You never run up in front of a deer when he's been shot," Russ tells me. "If you've stunned him and he comes to, you're in deep shit. A chest full of tines will make you wish you'd come in from behind." Once they had determined that it was dead, Russ and Murphy dragged the ten-pointer out of the brush. As Murphy watched, he could detect a subtle swagger in his grandson's movements.

Russ tells me that the boy's arrogance was quickly dispelled by the next step of his induction into the fraternity of hunters. Gutting is, ordinarily, the responsibility of the man who shot the deer. This time, Russ did the honors (as do many uncles) of instructing the boy. After laying out the deer on its side and swinging one of the hind legs around to reveal its underside, he had two of the other hunters hold down the legs while he dropped to his knees. The boy was filled with trepidation as he imagined what was about to happen. He'd done this with brook trout, but a full-grown buck was another story. As Russ straddled the deer, with the boy kneeling beside him, he explained that one must make an incision from the breastbone to the testicles while taking care not to go too deep. Cutting open the intestines or the bladder would quickly destroy the best meat.

Russ reached into his sheath, drew his knife, and began. He mistakenly hit the breastbone. The blade broke, and he angrily flung it into the pond. Murphy, the eldest brother, handed Russ his knife and said "You should be using this one, anyway!" As Russ thrust the knife into the deer's abdomen, he yelled "Here's one for you, Dad!" Russ explained that this was their late father's knife. Since his death, the brothers had made a tradition of honoring him in this way whenever they took a buck.

Drawing down the knife revealed the paunch. Gases and digestive odors wheezed out when the

blade grazed its now distended surface. Russ reared back with the blast of hot, fetid air. His nephew lurched to the side, vomiting. Russ had done this often enough to be able to fight off his own nausea, but the boy's visceral reaction was normal. Russ kept moving the knife. He understood the boy's reaction. This was confrontation with death, guilt bordering upon horror for having taken the life of a handsome animal which now lay disemboweled. The boy had never witnessed this amount of blood, nor had he killed a mammal with organs that looked like those in the anatomical illustrations of humans in his biology book.

With the incision now complete, Russ turned to his nephew and gently ordered him to roll up his sleeves and lend a hand in extracting the innards. The boy wiped his mouth, rolled up the arms of his wool shirt, and reached toward the steaming organs. After the awful opening of the paunch, the boy was astonished at how inviting the warm interior of the chest cavity felt to his freezing-cold hands. As they pulled, the mass of organs slid out into the snow and was quickly severed from the trunk. It was over except for the deft removal of the liver and the heart for one of the hunters to carry back in the storage pocket of his hunting jacket. Russ handed the hot liver to the boy to hold until his fingers had warmed, after which the two of them dragged the deer to the pond to drain and wash out the remaining blood from the chest cavity. They were in relative darkness now. Looking up at the Seneca Range as they wiped their hands on their pants, they saw the reddish glow coming from behind them reflected by the white summits.

While Russ had been field-dressing the animal in preparation for the drag, one of the hunters had hatcheted a 4-foot piece of birch and had affixed a heavy rope to it. The other end of the rope was tied around the antlers, in close, in order to protect the tines while two or three hunters maneuvered the buck around trees during the long return to the truck. The drag began with the boy in the center, flanked by Murphy and Russ. The best woodsman was put in front and entrusted with reading the compass—an instrument which had to be trusted more than your intuition, according to Russ.

The drag—through some of the worse deadfall and swamp—took about 2 hours. Everybody was wet up to his waist by the time the group hit the logging road. The navigator had led them to within a quarter mile of the truck, and in another half hour the deer was loaded into the bed.

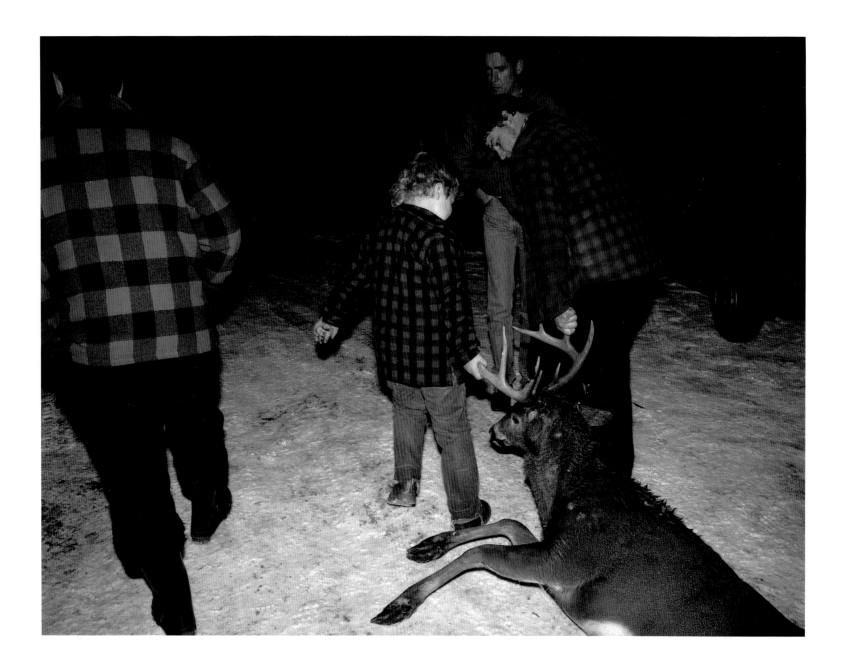

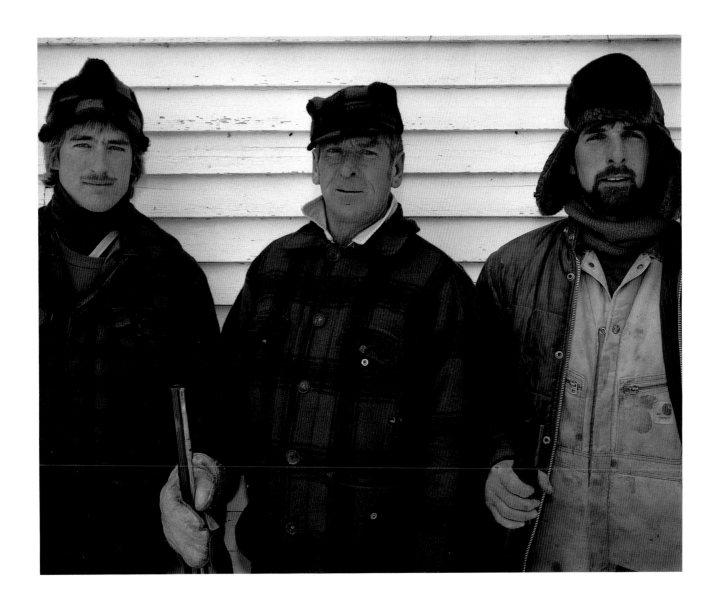

We have this, we have within each and every one of us, especially the male species of the human race, we have this innate sense of always wanting to go back to nature, and always wanting to provide, to be the winner of the game, to bring home the game, to bring home the meal, bring home the food, or something like that. That instinct is extremely, extremely embedded in us, you know.

The worst thing that a man can do, in the eyes of certain cultures, is to be a failure. Now a woman can fail, and finally make it back there, and be accepted. A man who fails many, many times is looked upon like a deer hunter who goes to deer camp and never gets a deer. He gets the most ribbing of any guy in the camp, until he does one of two things: he either moves to the back of the camp, or he moves to the back of the pack, like a wolf pack, and he becomes submissive all the time, you know, and there's always someone that's going to throw him a few tender vittles of venison, to make sure that he's fed, but he's always going to be at the bottom of the pecking order. . . .

—alcohol rehabilitation counselor

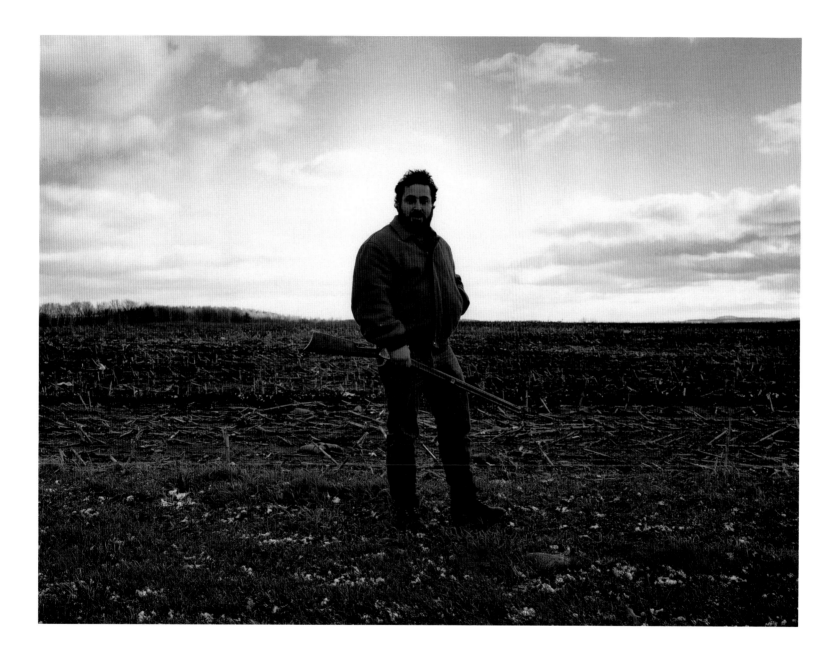

The next evening, with my pack frame adjusted, I reach into the car for my flashlight and then lock the door. I am in total silence in a snowstorm, about to start down a dark trail in the deepest part of the Northeast Kingdom. I am not sure that the hunting camp I'm looking for lies ahead, and I wonder if my flashlight will last for the trek in. Even worse, what if there is no camp at all after the dark mile or so? How will I know if I've walked a mile? Just getting my loaded pack onto my back has sapped some of my energy, and my beer consumption hasn't helped.

The snowflakes have turned to heavy, wet masses which melt as they gather between my neck and my coat collar. Stepping off the logging road onto the trail is a slippery transition. The trail undulates around spruce and cedar stands into the deeper forest. Working my way over the rough surfaces with the pack isn't so bad until I step onto the snow-covered rime covering a deep puddle and my boot tops sink well below the surface. Both pairs of socks suck up icy water like sponges. I realize I am on an old log skidder or jeep road, and as I swing my light toward the trees at its edge I notice that bark has recently been torn off a number of them at about bumper level. The evidence of traffic puts me more at ease and, I imagine, warms my freezing feet.

I continue walking, stop for a few moments to listen for any sounds of people, and go on. After some distance, I think I hear faint voices, yet because of the snow I can't verify if they are coming from up ahead on the trail. Disorientation is very common in this area because the land is low, with small hills that can echo a voice many times before it reaches you. By the time you hear it, the perceived point of origin could be off by 180 degrees. I continue. Soon I see what appears to be a faint glow on the snow, and I think I hear sounds coming from the direction of the illumination. As I come within 200 feet of a small cabin, my lungs react to the pungency of snow-blown wood smoke.

As I revel in the romantic setting, the door opens and out come the large silhouettes of three or four men with flashlights. In the midst of their hollering and yelling, I hear the question "Who the hell is coming in from the woods?" My position in the darkness is aggressively illuminated by the first men out. From behind the intense beams now shining in my face, they ask, almost in unison, "Who the hell are you?" This is just what I imagined I might hear if my friend wasn't there or if he hadn't alerted them to my possible visit. How did they know I was out here? Had somebody walking to the outhouse seen my penlight?

"Is this the Bear's Paw?" I ask the man closest to me. As he replies that it is, I notice he has one

hand on his pistol. I introduce myself and ask if my friend Joe is at this camp. Someone runs into the cabin and yells "Joe, get your ass out of bed! Some photographer wants to see you!" The man with the pistol invites me in; the others follow close behind me, eyeing the backpack cautiously. After wiping my glasses, I spot Joe. He shakes my hand and introduces me to the others. A short fellow, probably in his forties, bounces over manically, clasps my right hand with both of his, and welcomes me to "God's country." His intense eyes are hardly visible behind a disproportionate growth of facial hair. On hearing his name—Sam—I realize I have met the tracker. One of the hunters helps me out of the pack, which we put into one of the cooler bedrooms to keep my camera lenses and my film from fogging. I peel down to my thermal underwear, which is still dry.

Although the supper hour is long past, my friend Joe asks if I'm hungry. I diplomatically ask if I might make myself a sandwich. Joe goes out to the cold storage area in the entryway to bring in some hamburger and macaroni for reheating. I don't want to sound like a sponge, so I mention that I have a couple of six-packs in my car for the camp. Guy, the owner of the camp, says we'll go out and get those after I eat.

Many of the men in this camp work in the logging industry, some in the woods and some as truck drivers. Sam tells me that as children he and his brothers and sisters were supported entirely by their father's trapping and hunting. Many of the other members, including Guy's wife, Lorraine, had parents who either worked in the woods or spent much of their leisure time there, and this influence is evident whenever we discuss various aspects of forestry and wildlife. Their knowledge is based upon a lifetime of repeated observation and shared woods lore.

As we talk I gaze around the camp's walls, which are decorated with memorabilia and antlers. Rifles are on one wall, pots and pans on another. A toilet seat hangs behind the wood stove for trips to the outhouse on cold nights. Over the stove, suspended by a heavy steel cable lag-bolted to the ceiling, is a panel from the protective cage of a skidder. Hanging horizontally, it supports many inverted pairs of boots, socks, and gloves, some wet kindling, and other items to be dried. I am surprised by the order within this small space. Each person appears to have responsibilities: Joe for cooking, Guy for washing dishes, Sam for outsmarting deer, and so on. Guy maintains control, particularly when Sam "gets to carrying on."

I'm invited for the first round of poker. Having lost miserably at the Liar's Club earlier in the season, I'm delighted to hear it's penny ante. I begin losing, as I did the week before. After a few beers,

I try bluffing Sam. This makes him jumpy. I back off when his nostrils flare slightly. Last Friday, at the Liar's Club, I had questioned a player about divvying the winnings, and he had responded by plunging his Bowie knife through a stack of dollar bills and deep into the oak table below.

Now it's five card stud, low hold card wild. My focus shifts from my cards to Guy, whose attention is riveted on an 8-foot-high ledge behind the sink and the food cabinets. I can't see what he's staring at, but as he quietly lays his hand down I see Sam do the same.

Somebody yells "See him near the bread cabinet?" I turn to Guy's wife, Lorraine, and she explains: "Mice!" Sam and Guy jump up and pull out their .22 caliber revolvers (which have been inhibiting some of my bluffing). Guy fires the first round. Then Sam jumps up on the nearby bed and starts blasting away. I slide my chair back and dive under the poker table.

Then Joe gets up and pulls a .357 magnum from his leg holster. I beg to Jesus the mouse has disappeared. As he pulls the hammer back, more people join me under the table. Sam and Guy stop firing. Since the mouse has long since evaded the hunters, Joe carefully sets his pistol's hammer on safety, to everybody's relief. Guy breaks the silence by offering everybody another beer. Emerging from beneath the table, I am happy to see Joe snapping the leather guard over his pistol. We all take a break to relieve outselves and grab a beer outside. All the pistols are stashed, and the poker game resumes with a new intensity.

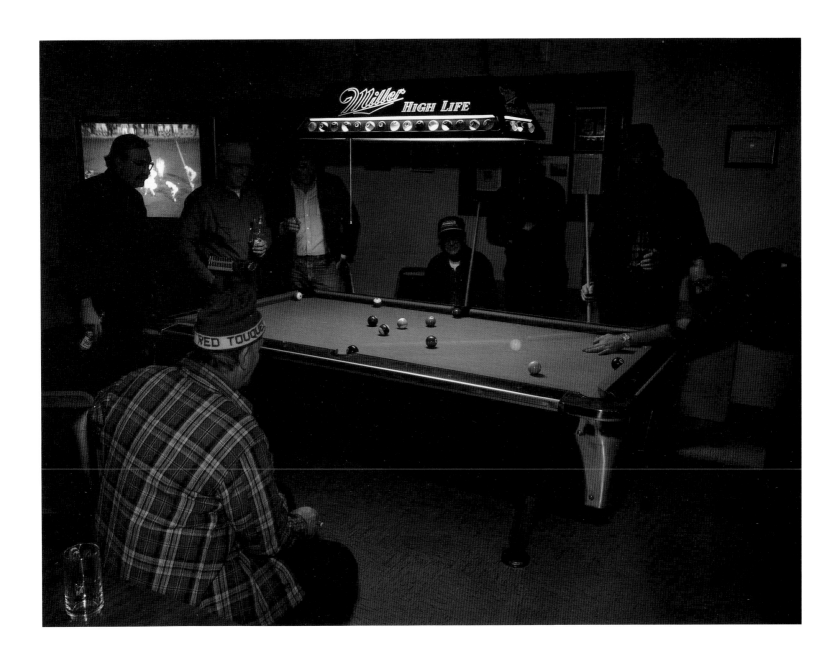

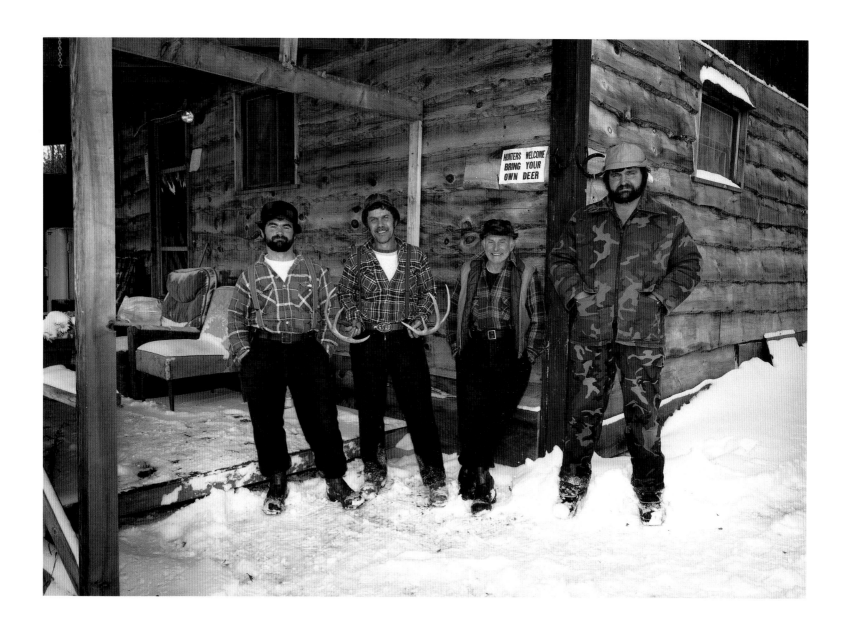

. . . I knew a guy in deer camp one time who did something . . . pretty marvelous now. He knew that there was at least two or three good, big deer out around the camp area. Where this particular camp, where it was placed, it really was a beautiful setting, because it was placed right in the middle of about four different farms. . . . A lot of meadows, and a lot of alfalfa, and clover, a lot of fringe areas, a lot of hedgerows. . . . There was apples, and fruit, and stuff like that.

. . . This one guy, who was the cook in the camp, had been going there for two or three years, and they had some luck, and they hadn't had some luck, and this one cook always got, he usually got a pretty good size deer every year, he was always fortunate to get a good, big deer, but the talk got so heated, and so excited, about one of those guys getting one of those big eight-, ten-pointers, or twelve-pointers, or whatever, one of those big deer that they'd seen around there all summer, that . . . it got to the point where they were starting to place bets on who was going to get the deer.

They also had this little hedge about who was going to get it first, who was going to be the first one to come into camp and get the deer. Well, the cook had it all planned. This goes to show you what people will do, in deer camp, to go to great lengths to get deer. The cook decided to make a chili. The night before deer season, the cook laced the chili with Ex-Lax, but he saved out a bowl, for himself, without Ex-Lax. Do you get the picture now?

He gets up the next morning, fixes breakfast, and everybody starts running to the outhouse. When he finishes breakfast, he's out. About an hour later, he's back, with a big twelve-pointer. And the rest of them are in there taking turns going to the john. . . . He's no longer the cook! . . . But think of that now, think of that, going to that extreme, so that you can win.''

—alcohol rehabilitation counselor

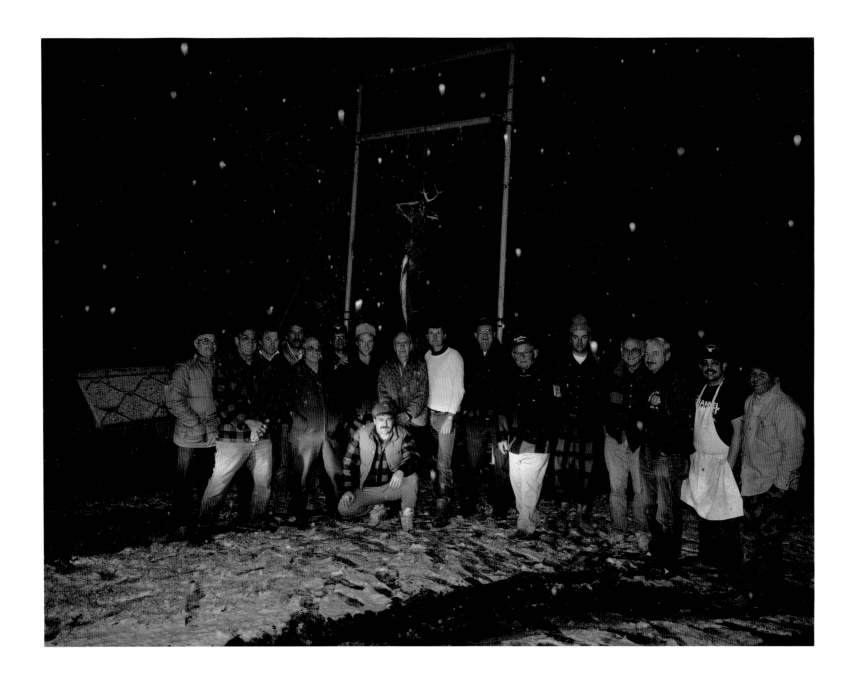

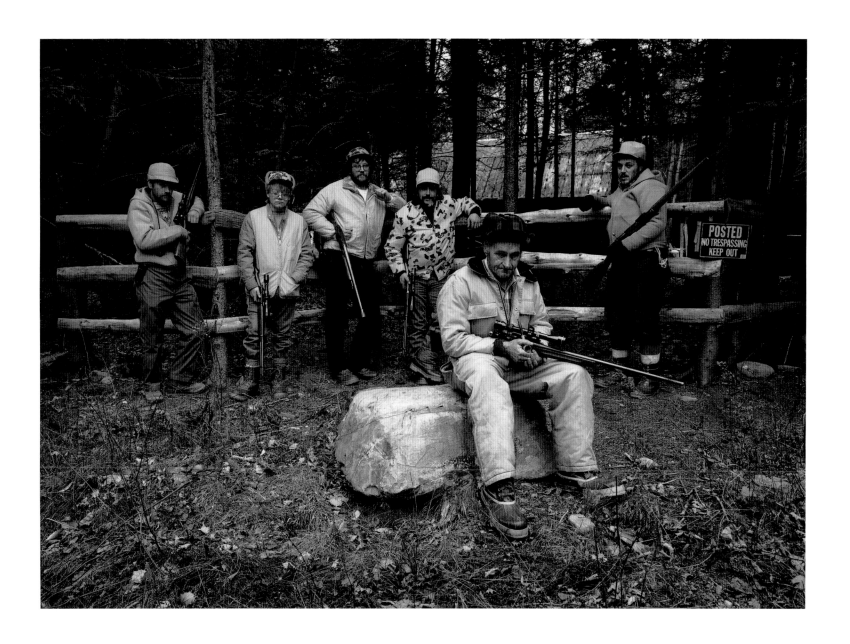

. . . Deer hunting season, that was the big one. You just couldn't interfere with that in any way. I know I resented it, but I never voiced that. I went along with it, but I didn't really like it very much. 'Cause I remember saying afterwards if you're ever gonna have a baby, for God's sake don't have it during hunting season time! 'Cause you're not gonna get any help at all! . . . Or plan a surgery or anything else, not then. Any big issue cannot happen at that time. It wouldn't have occurred to him, I don't think, and that's again the unjustness of it.

—crafts shop proprietress

I was married to my first husband 21 years. He was a sick man supposedly . . . wasn't supposed to go into the woods, no lifting. Wasn't supposed to have an active sex life. Wasn't supposed to do anything! . . . When he'd go to camp he'd sigh "Oh, I won't be around much longer." Then he'd have to go up and dance his butt off! After my husband died, I had his best friend and hunting buddy in the house. I was telling how my husband couldn't move around much at all. After the funeral, some of the hunters talked about times they'd go up dancing. He would dance. He'd never miss a dance. We never danced, because he had a heart problem. And I never found out half the stuff until after he died. I'm not a jealous woman. If they've got to go, they've got to go. I never worry about nothing I don't know about. If it makes you happier chasing a deer around the woods or a woman, chase them!

When I met my second husband . . . I was a waitress. I said "Before one of us gets interested, do you like to fish and hunt?" He said "I can take it or leave it alone," and I said "Good, because if you said you liked it I was going to tell you to take a hike right now!"

—retired social worker

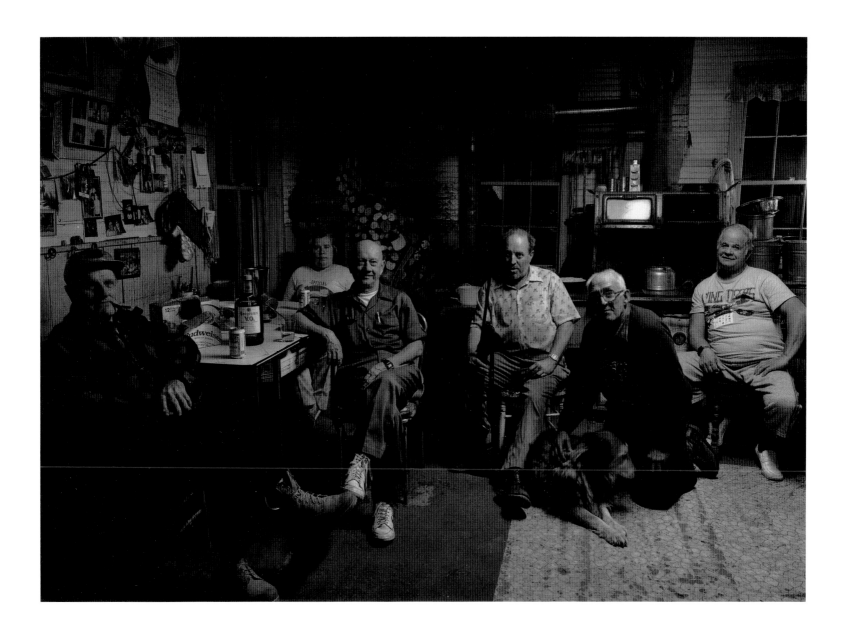

I don't know as I amounted to anything. But maybe there's one more deer runnin' around here that wouldn't have been if I hadn't been a deputy. I certainly didn't go into the deputy force for the money. I got $4 a day. In deer season in quarterly reports, very seldom under 18 hours a day. When I started as a deputy, money wasn't mentioned because you knew there wasn't any. Hey, I was allowed ten days for deer season. And I would start work in September, nights, for nothing.

We would leave between 8 and 10 at night. And if we had a lot going on I might get back by 4 in the morning, sometimes 2 . . . then I'd get up at 6 and start chores. Did this for 28 years.

And it was the time of year when everything was pretty well done, like the woodpile and the hay was done and all that stuff. They were good, the boys pitched right in and helped. As I said, without my family's support I couldn't have done this, not in the occupation I was in. Had I been working for anybody else, I couldn't have done it because I couldn't have had the time off to do what I did.

This is the time when wardens were out on their snowshoes. This was before snow machines came along or anything like this. They got out there. This is where they learned. . . . They knew what was going on. They had a sense of their entire district.

Maybe not inch by inch, but certainly acre by acre, definitely.

We had reports that said we had a place to put in foot miles. And it was a lot of miles put in that column, I tell ya. It could vary from 2 to 9 miles in a day. We tried to keep it down because, you understand, you work all day out here, working deer season . . . and you're going to work that day, but you're gonna come home and have supper, then you gotta work all night that night. You previously have worked all night the night before too. You may have had an hour's sleep, you may not have had an hour's sleep when deer season starts. I know one warden told me that he finally realized one day he was having trouble. This man who had called in a complaint was showin' him where the tracks were, and this warden said "I can't see those tracks." And he said he had been 36 hours without any sleep. He said "I finally realized I wasn't any use to myself or anybody around me." Depending on the situation, if something came up you took care of it. That was the idea of it. You had nobody to turn it over to, you stayed with it and got it done.

—retired deputy game warden

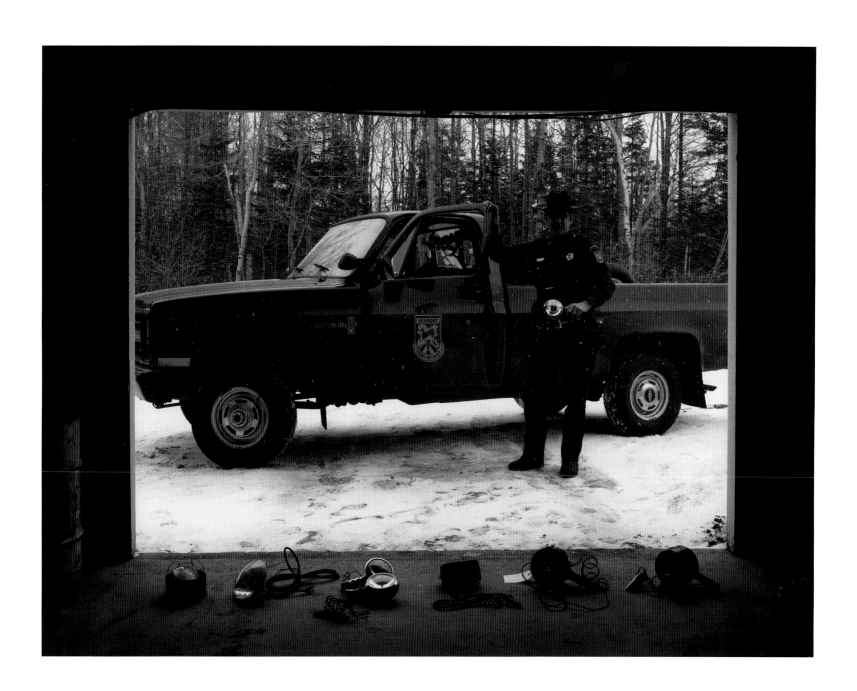

During my scouting, Raymond had recommended that I visit Homer, a game warden who was likely to have many stories about infamous hunters and their efforts to defy the law. When I arrived at his house the week before deer season, he immediately dove into the cellar and reappeared with his arms full of spotlights of every imaginable kind—some commercially manufactured and some homemade, some with cigarette-lighter plugs and some with sophisticated battery packs. Homer explained that the use of a spotlight gives a hunter an unfair advantage: a deer will freeze in the light beam, allowing the hunter to approach it for an easy shot.

"Deerjacking" with a spotlight, once a popular and legal sport in some states, is now a persistent problem for Vermont's game wardens. Homer grinned as be brought his collection of spotlights to the kitchen table. Every light had a story connected with it. For Homer, these lights were incriminating evidence; for some of the Vermonters who used them, they were simply tools used to keep meat on the table.

As Homer held up one light, he recalled a late-night chase at 70 miles per hour on back roads along the Black River. His description of the wild race over the curving, potholed dirt road made me wonder why he wasn't receiving hazardous-duty pay. Besides the inherent danger of such chases, the men being pursued were usually armed, often slightly intoxicated, and sometimes bitter toward wardens.

Another spotlight, this one quite worn, brings another story to mind. A few years back, Homer and another warden (my friend Gilles) had been on a stakeout in the summer just before second cutting of the hayfields—a time, according to one deerjacker, when the venison would be particularly sweet and tender because of the succulent feed in the pastures. Both wardens knew of a certain fellow's reputation for taking deer illegally, but they had been unable to apprehend him in the process. They had been bamboozled too many times, according to Homer, so they decided to concentrate their efforts to nail the offender.

From local sources, they had learned of late-night vehicular traffic in the northern part of the county, near the Canadian border. Gunshots had been heard, and a vehicle fitting the description of their suspect's had been identified. One clear evening, the wardens gambled that the fellow would return to a series of large fields set back a distance from the main road. That night the wardens were ready. When they came to the fields, they had to continue further up a dirt road to a second barway which allowed travel into a rough

pasture, now in decline and overgrown with Queen Anne's Lace and puckerbrush. By driving deep off the road from this point they were able to enter the far section of the mown field, prohibiting anyone from seeing their tire tracks. Homer parked his truck at the edge of the unused field; Gilles drove his vehicle across to the other side of the active pasture and then backed into the woods in order not to be seen in case the suspect swept his powerful beam across the field. The wardens had two-way radios in their trucks, which reduced the monotony of their vigil. An occasional car could be seen winding up along the highway toward the eastern townships or Richford; Homer could see their brake lights twinkle in the distance as they bumped over the many railroad crossings.

Homer kept his eyes fixed on the juncture between the dirt road and the paved road, to the south. His eyes ached. He'd rather close them and turn on some music, but then he would surely doze off. (He had been up half the night before helping another warden on a stakeout for moose poachers.) Soon after rolling down the window to cut his drowsiness, he heard a soft crackling on the road back to the east. The sound seemed to be moving, like car tires on gravel. As the sound turned to crunching, a vehicle stopped somewhere down near the entry to the field. Homer heard a

door open and came wide awake as he saw a light tracing quick arcs extending up toward the areas where he and Gilles were hiding. Then the light was extinguished, the door closed, and the vehicle seemed to head up into the field toward the two wardens in the darkness.

Homer was grinning as he told me this part, but the grin went away as he added a note of caution: "We didn't know who or how many were in the vehicle, but we guessed they were definitely there for one reason! When you have a truckload of boys out for a little fun with rifles, you're careful."

The truck continued north into the field and stopped much closer to the officers. This time they heard the doors on both sides open quietly. Homer wanted to know what Gilles was thinking but didn't dare use the radio, even at the lowest volume. In the fog that had now descended, sound would travel easily. He couldn't remember if his door squeaked, but he knew that the slightest sound would alert the jackers. Why hadn't he thought to open the goddamn thing when they were driving into the field? And how had the jackers sneaked up on them in the first place? Had they come in from the town road along the base of the mountain? If so, they would have had to unlock at least one gate and detach an electric fence, unless

the farmer had left the gate open. "We couldn't understand it," Homer told me as he banged the light on the table, rattling my coffee mug. "What were they doing out there? No time to be parking, mister! Couldn't see anything. They had no lights . . . they weren't talking."

A half hour passed. "I figured Gilles must be having a hemorrhage at this point," Homer said. Suddenly, the floodlight went on and Homer could see the tip of the truck's hood as somebody swept the light over the field. This time it was quickly shone in one direction, then turned off, then turned on again and pointed randomly in another direction. Fortunately, Gilles was backed into evergreens and Homer was obscured enough that the arc did not reveal his position. If there were weapons in the truck, the wardens already had enough evidence to arrest the driver. A law in Vermont states that merely shining one's headlights into a field while turning around is suspect.

Homer could hear muffled voices around the truck. The doors opened and closed. Then nothing. Should the warden make his move now, or should he wait for the jackers to shoot at the six-point decoy he and Gilles had so perfectly placed at the edge of the field? (They hadn't used this beauty many times yet. Looking to weigh about 160 pounds, it was easily visible at night with any

decent light.) They had an arrest, but did they have a solid conviction? The light hadn't hit the decoy yet.

Then Homer saw the beam sweep across Gilles' bumper and onto the decoy! He could see the reflectors on Gilles' truck, but had the jacker? When the full body of the decoy suddenly materialized in the beam, the light and the truck's engine were immediately extinguished. "Do something, goddammit," Homer whispered under his breath. He still couldn't open his door. Then he heard the unmistakable sound of a bolt closing down on a cartridge. On went the light, and a shot rang out. The light was put out immediately as the gun's report was still ringing in Homer's left ear. When the light came on again, the "deer" was still standing in the same position! Out it went again. Homer wondered what that poor jacker was thinking now. The light went on again, followed by another report from the rifle, followed by darkness and silence. After waiting a few minutes, the jacker turned the light on one more time. There was the upright buck, unscathed. The truck's engine started up, the headlights came on, and the truck skidded and slithered across the field toward the barway at high speed. As Homer turned on his lights, he caught sight of Gilles, who was already flying across the field on a collision

course with the jacker's truck, which was racing toward the single-lane barway. If the jacker had not slowed at the last moment, one or both of the vehicles might have plowed into a 4-foot wall of granite and puddingstone. After halting, the jacker jumped out of his truck knowing there was no chance to escape.

Now it was the wardens' turn to flash their search beams. Much to the wardens' annoyance, the jacker ran up to them as they got out of their vehicles and said "Hi, Homer; hi, Gilles. Congratulations! You finally caught me." He shook their hands and called to his accomplice. A young boy jumped out of the cab and proudly stood at his father's side. The nocturnal hunter put his arm around his son and proclaimed "My father supported our family with jacked deer, I get meat for my family, and I don't want my son to have to go begging for food stamps or welfare!"

Whether to arrest the jacker was something of a difficult decision for the wardens. Perhaps the family really was poor, and the meat was indeed important to them. And the young man's connection with his father and grandfather suggested that deerjacking was, for them, a familial inheritance. Although the intention was there, this fellow hadn't really shot a live deer—yet both wardens suspected that he had in the past. A deerjacker usually takes more than one deer a year. Some only use the venison to feed their families, but some sell a little "to pay some medical bills" and the greedier ones sell a lot to downcountry markets. This only hurts hunting for the rest.

Homer and Gilles handcuffed the deerjacker and put him in the back seat of Homer's vehicle. The son joined his father while Gilles went back up into the field to retrieve the decoy (which was no worse for wear except that one glass eye had been pulverized).

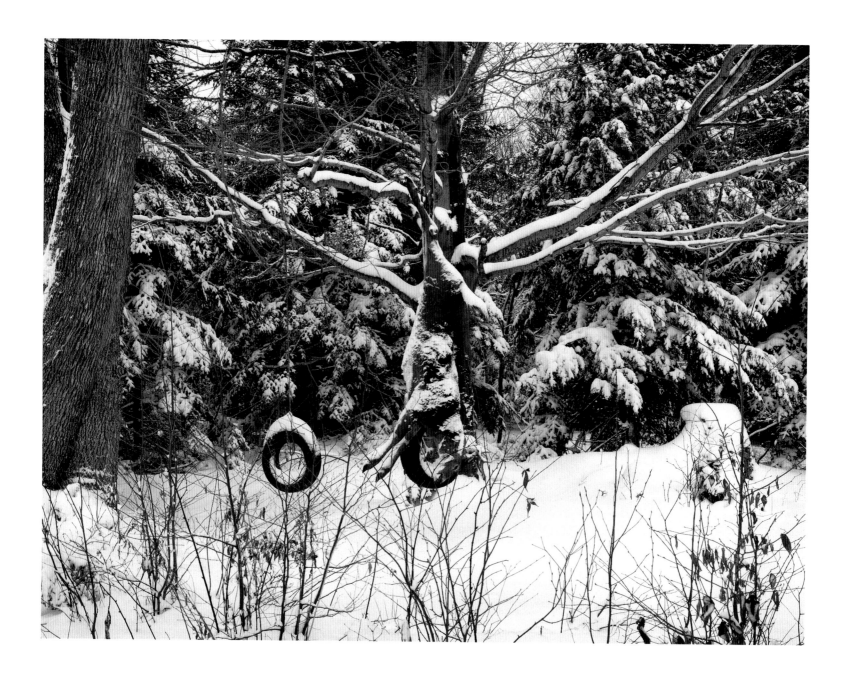

I am particularly looking forward to visiting Gaston and Marcel. Raymond's map of the Black River Valley offers seemingly good directions from the main road, yet as I near the turnout I have to recheck the map to confirm that this is indeed the road. It appears more like a private driveway into a number of mobile homes set back from the highway. I proceed, in fact, so close to one trailer I can see running football players on the television screen within.

As I climb up the precipitous driveway, the first confirmation that I'm at the right place is the sight of two large deer hanging from a heavily constructed horizontal support 10 feet above the ground. Raymond wasn't kidding—there are enough metal rings to handle eight more. The driveway and the yard are full of vehicles, including a Volkswagen bug, a few Broncos, and many rusty pickups with 55-gallon oil drums in their beds. The upper portion of the camp's gable end projects over a large porch to shelter it from rain, snow, and the summer sun. The front door is almost blocked by cordwood and cases of beer and soda. The camp appears unusually quiet as I get out of my car. A young woman comes out the front door and asks if she can help. When I explain who I am, she remembers one of her brothers mentioning a possible visit from a photographer.

I ask where everybody is; she explains a few people are inside but most are on the ridge above the camp. They are to be down within the hour. I ask how many are hunting. She pauses. "Probably twenty or more." Most of the hunters had gone out before light this morning, and few had returned. As we talk, our attention turns to the cliff far above the camp, where we hear shouting. In the gray light, small orange specks descend from the ridge toward us.

Now some hunters come around the corner of the camp from the woods to the north. One is a fellow my age, tall, robust, and not dressed in orange. He is followed by two boys in their early teens. He introduces himself as Gaston. As I shake his hand, I remind him of our telephone conversation the previous week. In what is to become a frequent refrain, he yells to one of the children on the porch "Get John another beer!" By then I have consumed the first, given to me by the young woman, so I sociably accept another. He all but drags me over to look at his first buck. His brother Luc, who claims the other one, is in the camp resting. We call him out so I can take a photograph of the brothers with their deer.

Now some of the hunters I had seen on the ridge are beginning to filter in. They razz the two having their portrait taken: "Bullshit luck!"

"Took six shots, and the last one was mine!" Luc and Gaston fidget as I coax them to watch me and the camera. More men, women, and children arrive now, all carrying rifles and many dressed in orange. Gaston explains they always bring the whole clan to camp, and he and most of his brothers often go into the woods with their wives and children to hunt together as a family all day. This doesn't always allow for serious hunting, he notes, but it is the best time the family spends together all year. He emphasizes that they really are out there to enjoy themselves and the woods. It doesn't matter if anyone sees a deer or not—and if somebody does, it's just as much fun to see a buck or a doe running through the woods as to shoot at it.

As we are standing around the pole, more trucks lurch into the driveway. While all this traffic is arriving, some of the children begin firing at a life-size deer target placed near the driveway. With each report of the pistol, the babies shriek. Though I don't want to show my distaste for gunfire, I stiffen slightly. Those of us who are still enjoying what we think is daylight are invited by those inside to come in out of the dark.

I stow my camera case in the car and enter the wonderfully rustic camp, with its log walls, its old furniture, its long, solid plank for a dining table, and its many deer heads. In one corner is a mounted pheasant in flight, and the main wall, above a beat-up couch, displays a 4-foot fan of wild turkey wings. Children are everywhere. The open sleeping loft is accessible only by means of a rough-hewn ladder. Climbing up after being invited by one of the youngsters, I see that twenty-plus hunters can be easily accommodated. I am surprised by the amount of light produced by the gas lamps. The large loft is bathed in a warm glow as the light reflects off its log walls.

I am asked if I can stay for some venison. As a child in Coventry, I would have it at a neighbor's house in the fall. Then I thought it tasted too wild—kind of like liver, which I detest no matter what animal it is from and which I can't help thinking of as the body's dumping ground for toxic chemicals. As an adult, I have grown to enjoy venison when it is properly butchered and prepared. I accept the invitation to stay for dinner this evening.

Some women in the main room of the camp begin to cut onions and potatoes into two frying pans. One hunter, who had refused to come out of the woods empty-handed, arrives with a partridge, which is immediately dressed and put into another pan on one of two gas stoves. The aroma of the partridge sautéing in bacon fat permeates

the space. Marcel and Gaston, with many of the children tagging along, step out to begin butchering Gaston's deer. One of the pickups is driven up to illuminate the scene with its headlights and its halogen auxiliary lamps. The men strip part of the hide to reveal tenderloin. Children run all over the yard, ducking into the lights periodically for a quick glimpse of the blood before returning to the security of the darkness.

This is one evening event I have never witnessed, so I trip my way down the front stairs to get a camera and a flash. As I move closer to the group, one of the younger men holds open the abdomen of Gaston's deer as Marcel, the best butcher, subtly runs his razor-sharp hunting knife down the vertebrae along the haunches. A long strip of meat curls into the hands of a young boy; he slings the 10-pound piece over his shoulder, runs through the darkness into the camp, and hands it to his mother. The first strips carried in are thinly sliced and are thrown into a pan to be cooked in butter and caramelized onion. I continue to take photographs outside. Each burst of my flash initiates a screech from a hunter who is either momentarily blinded or embarrassedly caught in mid-stream.

Before long, one of the children calls from the porch that dinner is ready. The truck's lights and engine are turned off, and we feel our way across the ground and up the porch steps to be blasted by the aroma of onions and game. This contrast with the cold evening air constitutes what sweet memories are made of: pure and total sensual indulgence.

A plate of partridge hors d'oeuvres is thrust at me. The rich, sweet meat makes chicken taste like dust. Large platters of venison, potatoes, onions, and salad are brought to the main dining table. By this time, there must be thirty people in the camp. Icy beers are brought in by the armful as everybody scrambles for a seat near the deer meat; I somehow get the end seat near the stove. Before a platter is emptied, it is replenished with more steaming venison from the pan. Visiting hunters begin to arrive from Brownington and other neighboring ridges on the opposite side of the valley. The word has gotten out that there are deer hanging at this camp, and everybody is hoping that venison may be served this evening. Marcel spirals a can of beer through the air to each newcomer; occasionally one bounces off the wall, and those sitting nearby get sprayed when it is opened. After the eating subsides, I find that the beer has lubricated the minds of most of the after-dinner storytellers. Each story is better and more imaginative than the last, usually with a similar theme

but a different cast of characters. When I look at my watch, Marcel offers me a bed if I want to stay or plenty of coffee if I decide to slither down off their mountain in my car and return to Coventry.

Around midnight I thank the few stragglers at the table, bid them goodnight, and trip out the door and down the stairs to search for my car, which is parked somewhere between my memory and the woods. Swearing somehow helps me locate the errant vehicle in the pitch blackness. The track down the hill is steep and slippery. Laying off the brakes, I do little more than hold onto the wheel as gravity pushes me down into the gully and up the next hill, then over and down the next incline. The sight of the main road comes as a surprise, and I use both feet on the brake pedal to keep from landing in the puckerbrush on the other side. The next morning, when I see the dried mud halfway up the side of the car, I remark to myself how much fun I must have had the previous evening.

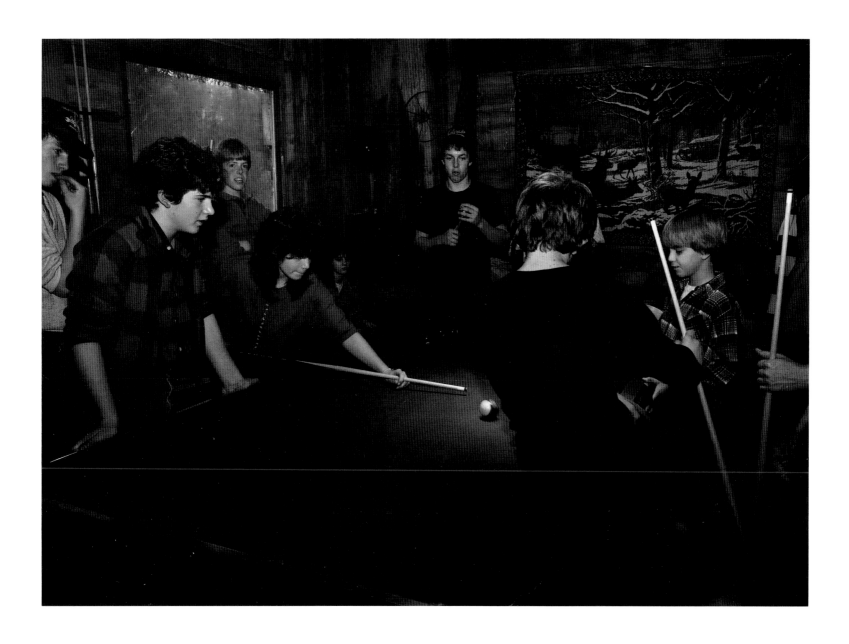

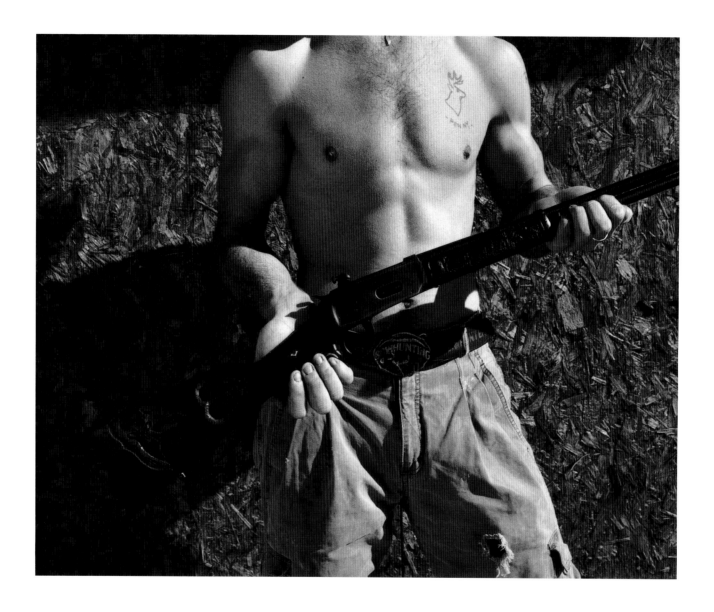

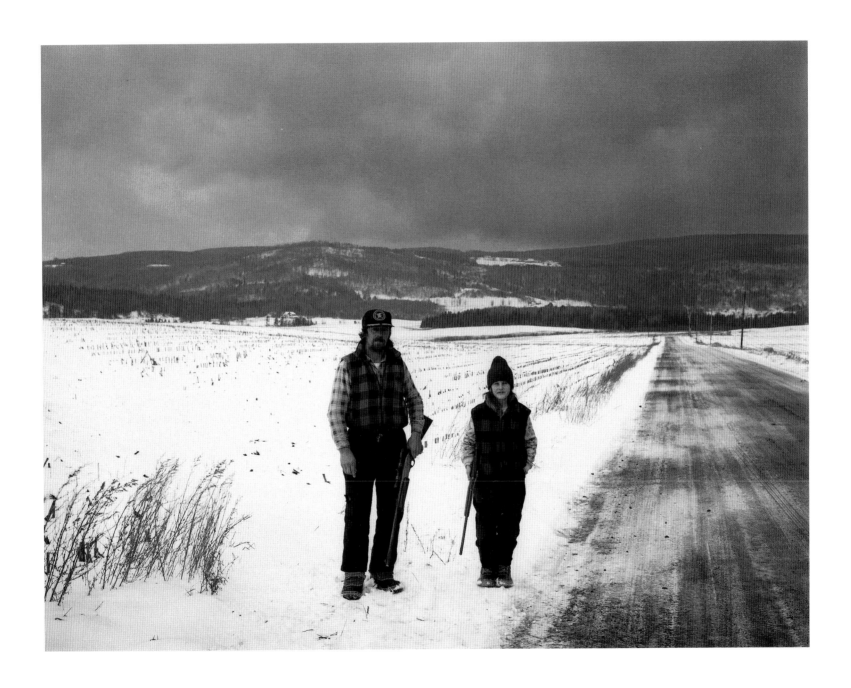

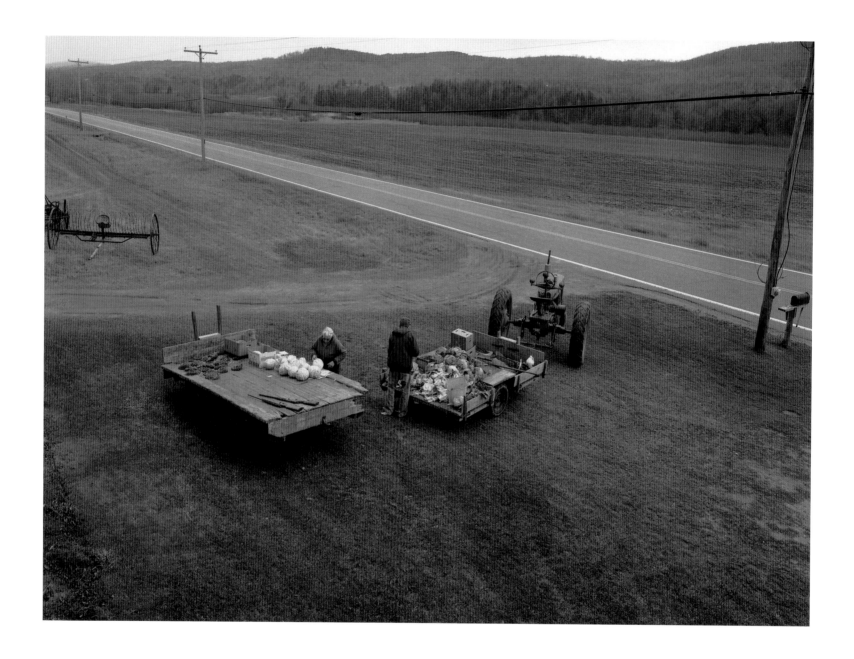

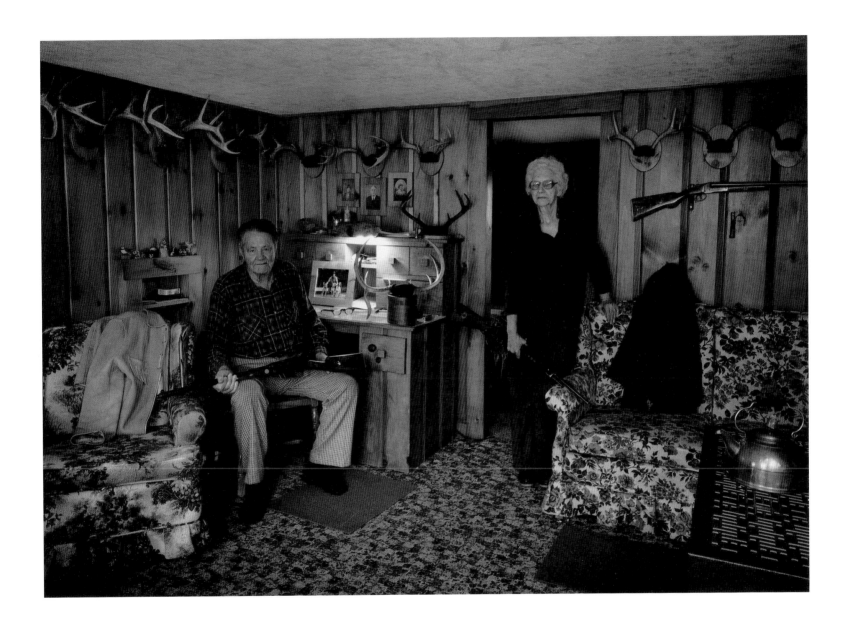

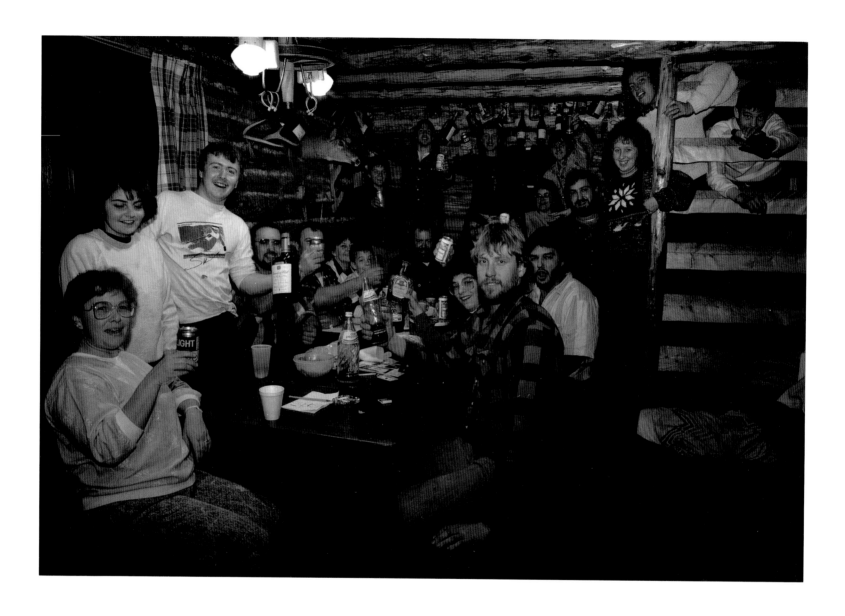

I can't honestly say that I have ever had buck fever. I've never fell apart, I've never emptied my gun out. But as soon as I see the deer, I'm aware of what that feels like. That kind of an electrifying feeling that goes through ya. It's a charge of adrenalin. You're fired then. Your instinct, what little you do have of it, to try to outsmart and to kill that deer, all comes into place. A little move at a time, watch him, don't blink your eyes, don't move. Breathe real slow so you aren't makin' a great big cloud of steam out there that he can see. All kinds of things take place.

—*immigration officer*

. . . He said when he saw a deer, everything else turned gray. It's a mental thing of course. . . . Everything around the deer just kind of blanked out gray.''

—*itinerant carpenter*

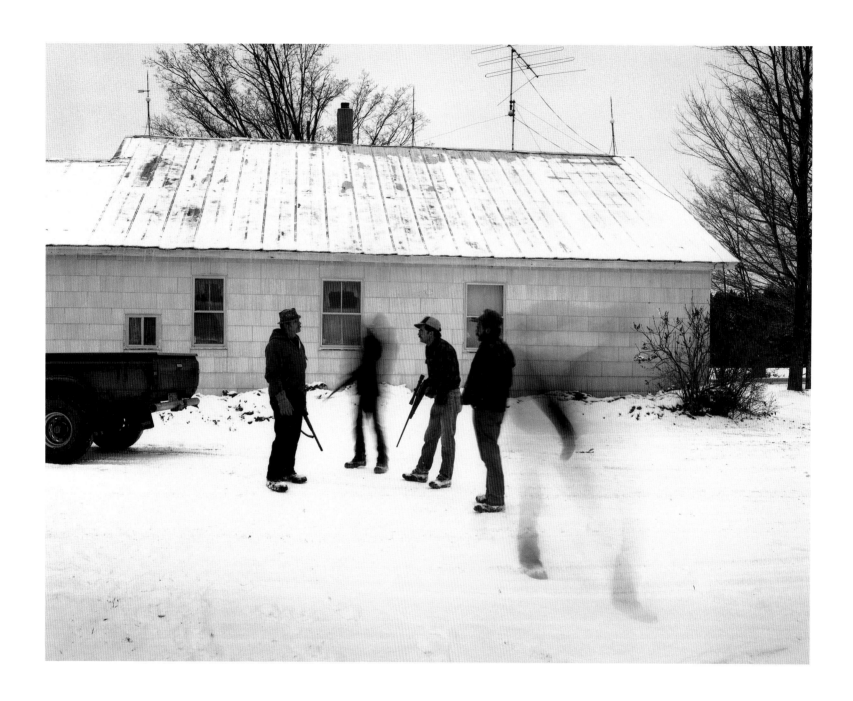

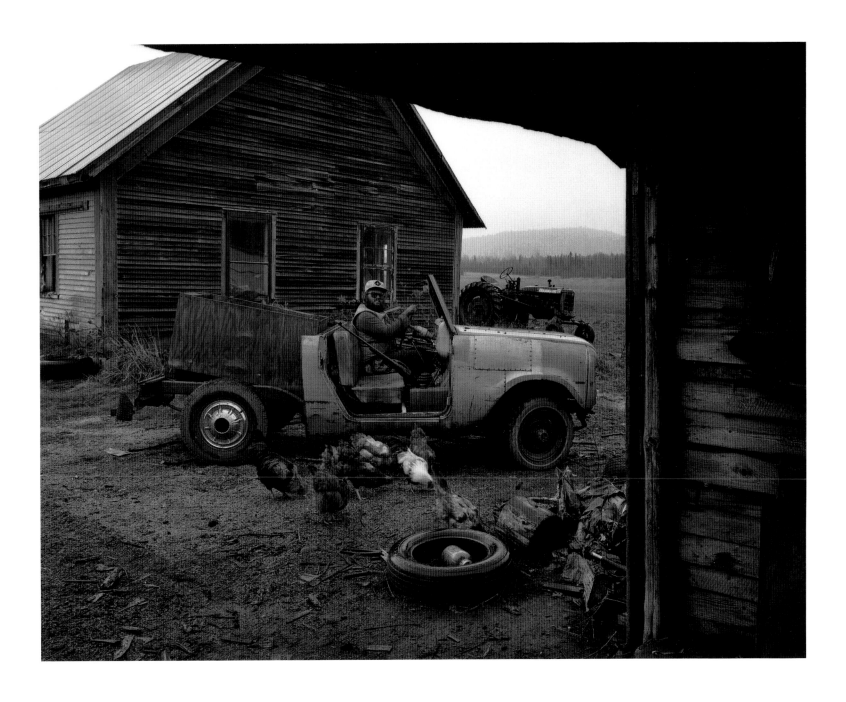

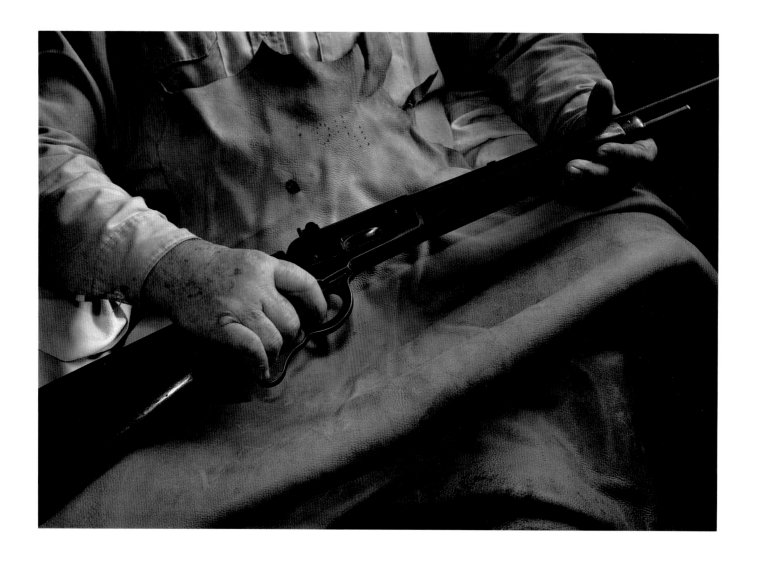

By the second Friday of hunting season, with only three days left, my senses are dull from exhaustion. I stare at my half-eaten donut. After some effort, and more coffee, I finish the donut, which seems more tasteless than usual. I look forward to visiting Mel this morning. A retired milk inspector, he has been a part-time gun dealer for 40 years.

Thinking of Mel reminds me of my first weapon. When I was 12, after naive negotiations with a hardware dealer in Newport, I became the proud owner of a Model 1900 Winchester .22 for $5.00. Although the gun's stock and barrel were simple in design, I had been swayed by its ornate, reverse-curve trigger guard. Before firing the gun, I disassembled it, refinished the stock, and reblued the barrel in amateur fashion. Much to my disappointment, upon testing my hard-earned purchase in the village gravel pit, I found that it occasionally blew sparks from the breech. My interest in the rifle dwindled, and I was happy when my mother agreed to buy me a Fred Bear camouflage bow and a quiver of target arrows for my birthday.

After a few anecdotes, Mel had remembered me when I had phoned him before the season. He had invited me to visit toward the end of the season, "when business tapers off." After I had told him of my plans to go running around the woods in pursuit of hunters, he had promised to tell me some hunting stories from back in the 1930s.

This morning his shop looked as I remember it looking 27 years ago. The shop is in the two-bay garage of Mel's home. The guns are stored in racks along the walls, leaving enough room for a couple of sedans. Since it is rainy and cold, the doors are shut. I find the interior dark and uncomfortable. The air is pungent with gun oil and the faint odor of gasoline. In the dim light, I can make out twenty to thirty lever-action carbines on one wall, slight reflections off blued steel defining their presence against the dark wood paneling. Most are either Winchesters or Marlins: a .25-30, .30-30's, .32 Specials, and .35 calibers. Lever-action rifles of these calibers have long been favored for a young man's first hunts, yet many seasoned hunters prefer the same weapons. They are preferred for hunting the rough country with second-growth vegetation—easy to handle, they rarely jam, and their weight is distributed very well. And the bullet, which packs a menacing wallop, will travel straighter through hardwood whips. On another wall are bolt-action rifles in larger calibers, more suitable for long shots in open fields or open hardwoods. Some of the bolt-actions are fitted with scopes. There are even some old rifles with buckhorn sights. When a deer is running through woods, in close, a scope is

worthless, according to many of the older hunters. Yet a scope is better for lower light levels. The best all-around sight is the tang peep, for one's eye instinctively centers the front ivory bead within the rear aperture. Unlike a scope, a peep sight frees the hunter to follow a running deer with his peripheral vision as he centers the bead.

The garage has always been Mel's chosen space for conducting business and holding court during the season, when many hunters come to buy and sell guns or just to hear and relate hunting stories. Making ends meet has always been difficult in this area. According to Mel, the poorest hunters would rent a rifle for the season for $10. A deer taken with such a rented gun was "the cheapest meat money can buy." Most of the renters had been honest over the years. No contract or deposit was required. They'd bring the guns right back in Sunday night or Monday after the season—"And mister, they were cleaned! The men knew I'd rent again to them next year if they treated the gun decent." Only once did a renter fail to return his rifle. When Mel saw it again, a year or two later, a farmer was looking to sell it. "I had to tell him it was pretty difficult to buy your own gun back, having never sold it in the first place," says Mel.

Many a hunter purchases a fancy new rifle in the fall, goes out deer hunting for two weeks, comes back in with the unsoiled gun, and says he needs to sell it. Mel says he hates to see these hunters take the loss. Some of them probably need cash for Christmas presents for the kids; others will buy a boat for the spring, sell it next fall, and come back looking for another new rifle just before next deer season. "It's a vicious circle," says Mel, shaking his head. But that's the way it has always been done up here. "Can't afford to leave [cash] attached to one season."

By now I am cold, and I pace around the garage wondering how to kindly suggest that we move into the house. I ask about the old photographs Mel mentioned during our phone conversation two weeks before. They are in the house; however, Mel asks me to take a seat before he goes inside to get them. I plug in my tape recorder and sit on my hands to warm them so I can take notes.

Mel comes back carrying a lidless cigar box full of family memorabilia. A handful of snapshots sit on top, probably sorted out before my visit. Mel sits beside me on the bench with the box on his knees. The top image is that of a young man, many years ago, in coveralls and a tattered driving cap. The edges of the print are torn. There is a brief silence while Mel stares at it; then he tucks it below the other photographs without expla-

nation. He digs into the stack and pulls out a yellowing, faded print showing a house with attached sheds and a barn in the distance. Split-rail fences fade off into the emulsion. This was Mel's boyhood home, in Richford. "My father was a farmer," he tells me. "After his passing, we boys were the ones that operated the farm. Two of my brothers didn't care to hunt . . . didn't want to go into camp and rough it. But there were a couple of us who did. We hightailed it for somewhere every fall. The other two ran the farm."

Hunting was different in those days. It was for adults, not young fellows. "I was one of the lucky ones," Mel admits. This was, of course, before the state began promoting deer hunting, in the 1950s. "You know, John," he continues, "you'd never see a woman in the woods back then. I remember, back in the thirties, we were leaving Richford early. . . ." I glance down quickly at a snapshot of young boys, a middle-aged woman, and a dog before Mel skips to a photo of some old men lined up in front of a camp. They are dressed in hunting woolens with pants flared like jodhpurs. "My brother, my brother-in-law, myself, Jesse, and Mr. Inglis. I use to hunt with Will Inglis, and this was one of the last times that I ever went to camp with him. Of course, we kids all knew about Mr. Inglis and his driving, because

he was a hell driver. . . . been in plenty of fracases with that old '28 Hudson. Seems though it was about as long as a freight car, with a trunk on the back and a spare tire on the back of that. I'm telling you, we sure as hell didn't want a ride with him because, mister, he'd give you a ride you'd never forget. So, my brother and I, we rode with my brother-in-law in his Model A."

They had set out toward the Gore Woods in Belvidere. Mel, his brother Ted, and his brother-in-law Cecil had gone on ahead with the trailer carrying all the supplies. The unfortunate Jesse was left to ride with Mr. Inglis. "It's unbelievable what these photographs bring up," says Mel. "We were driving at a pretty good clip down towards Belvidere Bog when we came upon some of the Dudley boys walking towards the Mitchell camp at the Pond . . . a grain sack over their shoulder. They'd stuffed in their rifle, probably a box of cartridges to be shared amongst all of them, their change of socks, and food." The Dudleys had to walk because, other than Cecil and Mr. Inglis, there was nobody driving that direction this time of year. "They'd begun to walk in Berkshire, and by the time they got to camp they probably'd covered 20, 25 miles."

Coming down the side of the Green Mountains, Cecil carefully guided the Ford and the

trailer through a dangerous hairpin curve. "It was here," according to Mel, "that my brother decided we had better wait for Mr. Inglis." Mel chuckles when he recalls his brother's words: "The way he drives, we better get way down to the other end of the flat beyond the curve before we park." They waited and waited. And finally . . . "Oh boy! We could hear the drone of that ol' Hudson just a purrin', coming up over that hill. We kids ran up the road and waved our hands at him before he shot right past us." Mel remembers seeing Mr. Inglis fumbling for the hand brake. "Let me tell you. That old car squealed around the curve, and went into the most godawful skid right across and up the bank. Then, she careened back onto the flat with a KABAM, you know?" They ran up to the car, and there was Jess taking it easy, "just smokin' his pipe." Mr. Inglis got out and said "Well, by God, boys, I guess I'm here." He was reputedly hard of hearing. When Mel's brother Ted said "Now, you stay right behind us," Mr. Inglis nodded his head and said "Yeah, yeah, yeah."

They proceeded out of the Gore Woods, back by Big Muddy and Long Pond and over to Eden, then through Newport to Island Pond and on to where the Nulhegan River comes down. "Had to park our cars at the Paul John farm before Bernie

(a local farmer and logger) picked us up with his horses and dray. I'll never forget. Now that's a story." Mel flips through more prints, looking for an image he has in mind. "There was a bridge across the brook to the farm, and they'd cut second-growth stuff, popples and swamp maple, just poles really, and laid them down over these stringers. I remember hanging my head out the window, and how they rattled when my brother-in-law crept across and went up quite a grade to the yard. No problem. The poles weren't nailed down, of course. So Cecil walked down to Mr. Inglis and said 'Now, when you come across, just let that car idle. Take it slow now. Don't step on it!' 'Yeah, yeah, yeah,' said Mr. Inglis after cupping his ear. Jesus, he gets on that bridge, . . . throttles her wide open, and's up in the yard in two bounds, kicking everything out from below. Oh, my God! All you could see were these empty stringers . . . the poles looking like a stack of cordwood on the other side of the stream."

They unloaded the cars. Bernie was waiting with his draft horses for the trip into the woods. He'd taken the wheels off his wagon, according to Mel, because "only a dray could be snaked up through those spruces that'd been knotted in with scabby-ass birches, and what-not." "Some days," Mel continues, "it'd be raining and . . . miserable!

But we still went in. We'd load up all our things. Oh, a great big six-man tent, the sheet-metal stove, provisions our mothers and the wives had prepared. The guys would all walk and carry their guns in. Five miles too. Then, before we hit the Black Branch, we'd strike north." Mel could never understand how Cecil always had a place scouted out for the tent. Every year, it seems, "he just knew, using his instinct."

Mel sets the cigar box on the bench between us and continues the saga. Once they had cut poles, the tent was erected in a stand of spruce or fir. They cut evergreen boughs for their mattresses. "Nice soft, springy ones," says Mel, arching forward and wiggling his back. Nobody had sleeping bags in those days; they would roll themselves up in big, heavy horse blankets. "It got so cold some of those nights after hunting," Mel recalls, "you couldn't keep your head out unless you put on your cap. Gracious Peter . . . could see your breath by morning."

I ask how they prepared their food, and Mel tells me they carried a portable table, tin dishes and utensils, and frying pans. The younger fellows were chosen to look for an old tree, kind of dead and cured, and chop it down. "No chainsaws, just little old buck saws," Mel reminds me. "We'd store a pile of kindling inside the tent and

saw up the rest for cooking and heat. . . . Gracious be to the womenfolk who made the pies, the desserts, and bread." He pulls out a photograph of a middle-aged woman, probably his mother. "Always had beans and of course a little camp meat that was brushed under the rug." One man was given the duty of providing venison for the camp. The basic staples they carried in with them usually lasted about five days; then two of the boys were sent back to get the car, drive to Island Pond or North Stratford, purchase whatever was needed for the remainder of the season, drive back, leave the car, and carry the supplies to the camp in pack baskets.

Kerosene lamps were used in the camp and for tracking. "When tracking a wounded deer at night," Mel tells me, "you always want a kerosene lantern, not any damn flashlight." Lantern light reflects off spots of blood on grass or brush, making tracking much easier. And when looking for a lost hunter, the members of the search party won't stumble all over one another if the whole area around them is lit. "I remember seeing the older men going out, carrying that lantern toward where a hunter had fired his shots into the darkness. My brother was lost for three days and two nights in the Yellow Bogs. There was rain, terrible rain, and snow, and fog so thick we never

heard him shoot. He came upon an old logging camp. Started a fire in the stove. Burned the place down. Kept him warm through the night, though."

Mel begins to reminisce about some of the old-time hunters who could read the woods and landscape like a map. He believes they had more highly developed visual memories than present-day hunters. A good many of them didn't carry a compass. "No sir. They'd get a landmark like Black Mountain or Peanut Dam, then would hunt a certain direction and knew how to return. Then you might trek back a little further, time and again, until you really knew the territory. They were clever, because those gents used to roam a long, long way." In those days the area they hunted was a wilderness, with no logging roads. Mel recalls how the old-timers walked with their rifles almost to their shoulders. "They'd stalk very quietly and always, like an Indian, use their eyes and ears. Our youngsters now could learn a thing or two from those old boys. Most of them would walk and pause, walk and pause."

As I turn over my tape, Mel walks out to the shop and returns with a weathered lever-action carbine that reminds him of one of his first weapons. The entire rifle, stock and barrel, has numerous coats of varnish to protect it in foul weather.

As he cranks the lever down to open the chamber, he resumes his reminiscence. "I can remember when I first went. I used to go once in a while with Jess, who was real elderly. You never spoke . . . he didn't want you to do things, and you knew it after you'd been with him once or twice. And I just watched him. And by golly he'd pick out a deer and shoot it before I'd even seen it. And I was a young kid with sharper eyes than his. He had a great sense of seeing any kind of object. You don't find that today. I think maybe the reason was that deer meant an awful lot to an individual . . . like whether you had meat on the table during the winter months. Many times, it felt like a life-or-death deal to a hunter with the pressure to bring home food for his family, to say nothing of the weather and dangerous terrain. And remember, it was open sights in those days. Very seldom those guys missed. When someone did, he was disgusted. They'd talk about it for a week, how stupid they were . . . , and call themselves everything in the book because they missed that one shot."

After dinner, there was always some entertainment before wrapping up for sleep. "They had an old straight razor, and here I was, just a young fella, didn't have many whiskers anyway, but they always used Cecil or Ted and me as guinea

pigs . . . always wanted to keep trimming and shaving us, so we were foolish enough to let them. We almost needed a blood transfusion afterwards because they'd nick us up so."

It was Jess who traditionally got everybody up in the morning. He'd get up at 4 o'clock and feed some kindling and a few chunks of wood into the stove. Almost instantly, the stove and the chimney would begin to rattle as the wood caught. Mel recalls: "I'd roll over to see Jess in long johns, bathed in flickering light before closing the door when he was adding the chunk wood. He'd fumble his way back to his horse blanket until the tent warmed up. My brother and I would doze briefly until we heard the match being struck. Then, on came the lantern. He'd rout us out of those horse blankets, put on the coffee pot to boil, pound on the frying pan and holler and hoot. We'd get up, eat breakfast, get ready, and then have to wait until the sun came up a little bit, so we could see."

"Back in those days we always had oatmeal in the morning. Oatmeal and toast. Mr. Inglis said one morning 'Let me mix the oatmeal and stir it.' Poor fellow, couldn't see too well either. He says 'What is this, boys?' " Mel shakes his head with laughter as he tells how everybody had put their gloves around the stove to dry. It happened that one old brown glove had fallen into the oatmeal.

"We took sandwiches with us . . . never came back until dark. . . . When somebody was lucky enough to get a deer, say 5 or so miles back, there'd be at least four of us to drag him back. One time we were in a good 6 miles. Up to our necks in deadfall. Real swampy. Five of us taking turns dragging. Some of the men carried old Colt handguns. If I remember, it was getting on to late afternoon. We came upon this swamp. Rabbits all over the place. They pulled out those Colts and shot some. Boy, we dressed them all out and had a great big ol' regular rabbit stew down to camp. Skin and parboil 'em. Cook tender carrots and peas and things like that. Mix the meat all in with the white sauce and then made our baking powder biscuits. And then sometimes, you'd be so tired, having hunted so far from camp, you really didn't care whether you ate or not. Then it was to bed. . . . "But you know, Jesse and Cecil and Ted each got a deer. And that was back when you really needed it. The guys hunted every day just as hard as could be, just to get those deer for their family."

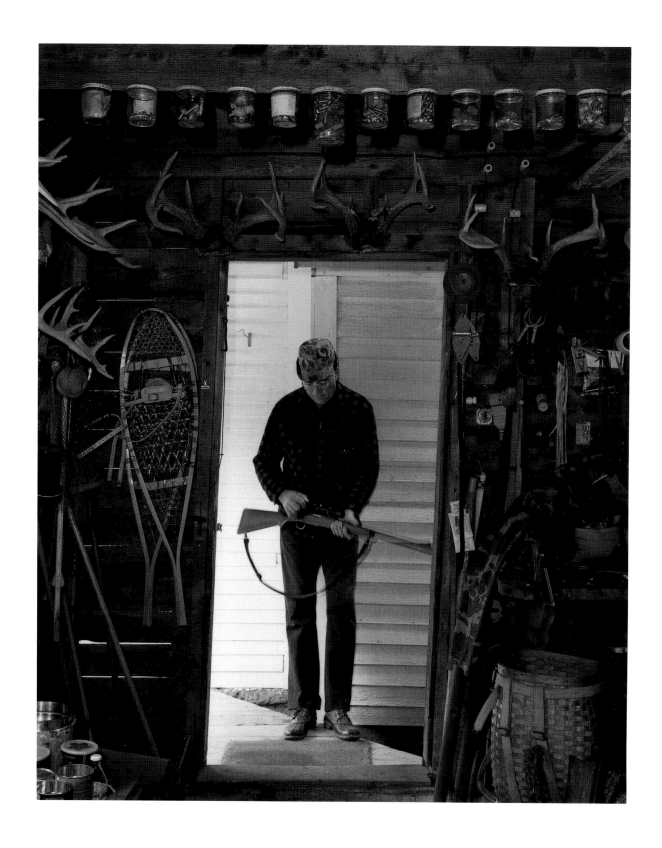

. . . All our good, big, heavy-rack deer all came off the mountain. We just say "the mountain." We don't call it the Senecas. We don't say the Bull or Little Bull. You know, the Bull's up there, the Little Bull's down here, big Seneca's here, little Seneca's there—we don't say that. We just say we hunt the mountain.

—railroad maintenance worker

We got some places out here we call First Cow and Second Cow. When we was farmin' we had cows die. My dad took and dragged the cow out where a deer crossed. And we'd go out and we'd hunt. Dad would say "Did you see anything?" [We would say] "Huge track over by the Second Cow." And he'd know right where it was.

I don't think there's anybody around here that knows these woods like us boys. . . . We've hunted so much around here that we almost know where, if we see a deer, where he's gonna go so we can see him again. Very seldom will he get by us. 'Cause we know, we were raised here. We were raised to set in the woods . . . wait for the deer, if it had horns shoot it. And camps around here. Like people from the city and they go in the woods and tramp around, I drive the deer right to them. That's the difference between knowin' the woods or not knowin' them."

—homemaker and her brothers

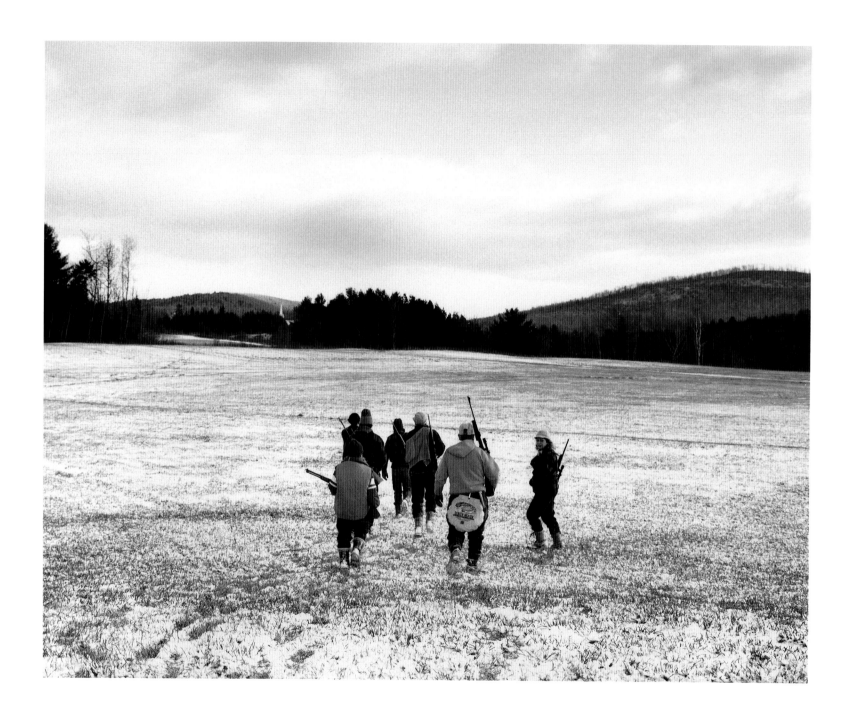

Older hunters often find "their" deer on ridges. In Essex County, a man who had hunted in the Seneca Mountains for 50 years once explained to me that a smart mountain buck will run the whole length of a ridge, because it can see both sides and because the draft, which a deer depends on to carry warning smells, is usually up. I remember him adding, emphatically, that this is something a hunter learns for himself, not out of any book. "But it takes a lifetime to learn it. And after you get it learnt you can't give it to nobody, 'cause they think you're lying to them."

This hunter of the Nulhegan region understood how cagey the whitetail deer could be. As I rattle across the covered bridge back to town, another of his anecdotes comes to mind: ". . . it was in the afternoon, and I was poking along, tracking and hunting. I see the track, then I'd look. He was right in the middle of the mountain going sideways. And every so often he'd swing to the left and head down lower toward the second-growth country. But he was in the open hard-wood. I said, I know what you're going to do. When you get ready, you're going up the mountain. So I walked along careful, another 10 to 15 rods. All to once he took a sharp cut to the left to the second growth—right down, down, down, down . . . right out of the hardwood. I stopped

right there, I said you're coming up the mountain, right up there. And I had my .25-06 with a scope on it. And I never did hunt with a fucking scope. But the rifle shoots dead perfect. And I look. Where is that sonofabitch through that fucking scope? If I had my old rifle, my peep sight. . . . Yet, that's what a deer will do. Just before he lays down he'll swing right off down like this. And then he'll go right back up the mountain, mister, and lay down up there. He'll see you coming, he'll see you going off down in there. That's when you got to be on the ball and read him!"

As I chuckle to myself over how shifty a deer can be, I recall a long evening with another old hunter who, as a young man, had favored the steep topography near the headwaters of the Boomhour Brook, deep in the Lowell Range. I was amazed to hear from him that a deer may not be alarmed by gunfire. You can shoot your gun, you can empty it—bang, bang, bang—right near a deer. The deer may raise its head and look, but deer hear similar sounds throughout the year. In the wintertime, deer become accustomed to trees popping with the frost, to the backfiring of logging trucks, and to the sounds of skidders and chainsaws. This old hunter liked to entertain deer with his harmonica when he was hunting. The deer's ears would come up, and it would look

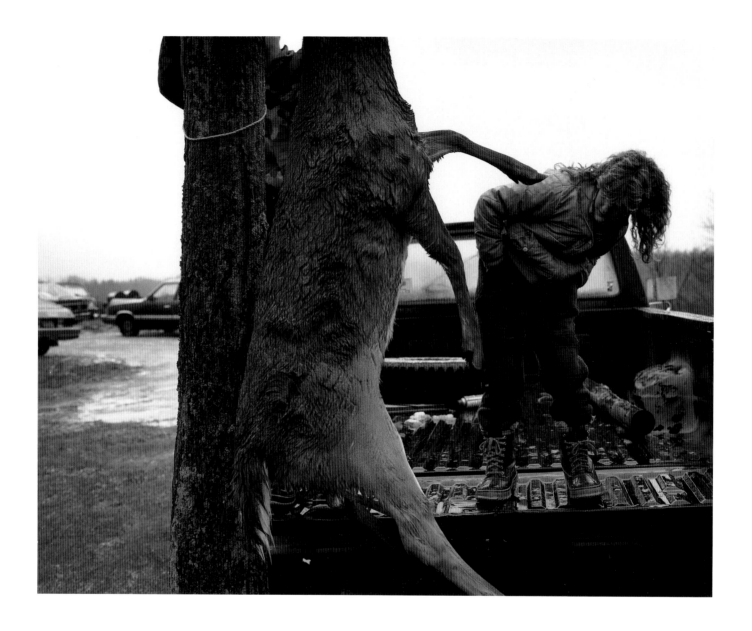

around some, but seldom would it be frightened—even if it was only 7 or 8 rods away. Sometimes he'd play two or three pieces, and the deer would often seem almost amused. "Deer are funny animals," he murmured.

Yet deer are reputed to be easily alarmed by certain smells. Once, at the diner, I heard a hunter admonish his young, enthusiastic brother never to wear a hunting jacket into a restaurant or a kitchen, where cooking odors might taint the coat indefinitely. During deer season, some hunters always go to the "full service" pump at a gas station in order to avoid the risk of spilling a little gasoline on their boots. Bow-and-arrow hunters often hang their camouflage garb outdoors to keep human-induced odors out of it, then stuff it in a garbage bag along with a rag soaked in "scentshield" or oil commercially extracted from the leaves or needles of trees near one's deer stand. The bag is always kept in the trunk of a car or the bed of a pickup.

As part of their preparation for deer season, hunters will scout an area for buck rubs on trees and saplings, scrapes on the ground, and food sources such as beech nuts and apples. The arrival of a number of hunters may cause the deer in an area to depart from their customary patterns of movement and feeding. From time to time, the human invasion will run a deer unexpectedly "onto" a hunter, creating a "once-in-a-lifetime chance"; however, many hunt every day, from before dawn till after dark, even through rain and snow, and still get "shut out," never seeing a "flag" or much "sign." All agree that "deer tracks make pretty lean soup."

Sam, the tracker at the Bear's Paw, was indignant toward those who got their deer at the expense of another hunter's hard work. As he pushed cartridges into the receiver of his father's .32 Special the morning after the poker game, he mentioned a scenario that he had witnessed more than once: "After a day of tracking—ridge-running, or crawling on all fours through spruce and hardwhack so thick, mister, that you think day is night—some hunter down on the road shoots your deer. You'd been in the woods at six that morning, . . . been tailing that buck for miles, and then, out ahead of you, . . . gunshots. That's right, goddammit . . . plural! Road hunters with their semi-automatics and Nikon cross-hairs can't drop the deer with one shot like my father taught me. Christ, get out to the road, and the deer's being loaded into the back of a Wagoneer. Bullshit luck! That's why I aim for the backbone, not behind the shoulder. One shot, and that deer's not traveling anywhere, other than at the end of my

dragline! Besides, my deer may not be dead but he won't know pain like the deer that got machine-gunned and paunch-shot by the friggin' flatlander."

Now I am back on the level gravel of the Gool. Several pickups pass, the cabs and the beds crammed with "road hunters." They may be looking for deer or for friends; more likely they are just "dubbing around," enjoying the midday warmth of November's sun and a touch of the fever. That word has a number of meanings in relation to deer season. "Buck fever" refers to that paralyzing moment when, upon observing a buck in your rifle sights, you can't pull the trigger. This stems from excitement (often associated with in-experienced hunters) or from guilt (a natural re-sponse before taking the life of such a magnificent animal). Fever, in the other context (as in my ref-erence to the hunters I saw on the road today), is the excitement that builds in early fall as hunters orient their thoughts and activities toward the ap-proaching season. This heartfelt feeling, so com-mon in rural Vermont, might be better described as a desire for the camaraderie of one's com-panions and for a ritualistic celebration of short

duration and great sensual bombardment. The challenge of the hunt, the anticipation of physical exertion, and the scarce chance of even seeing a deer are all elements of this fever.

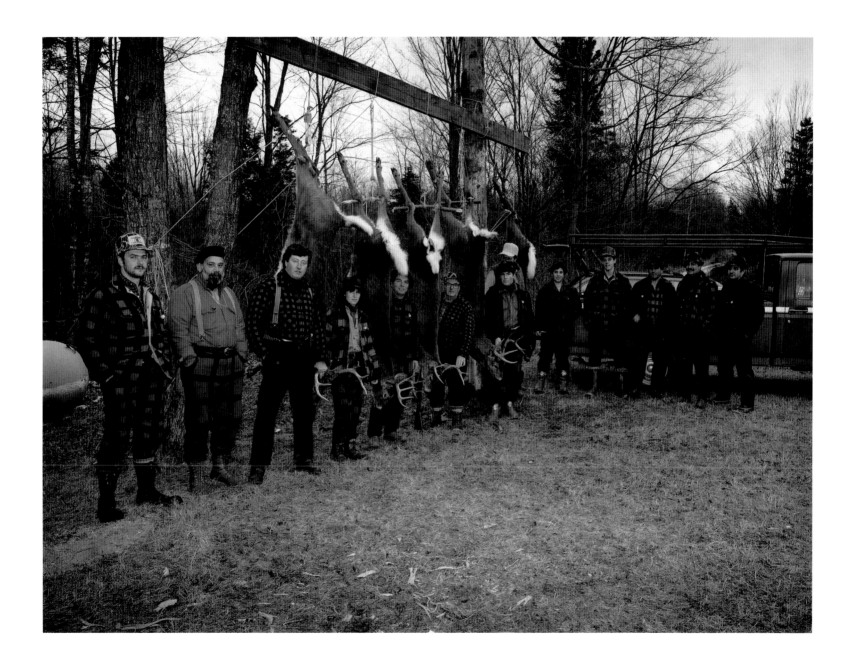

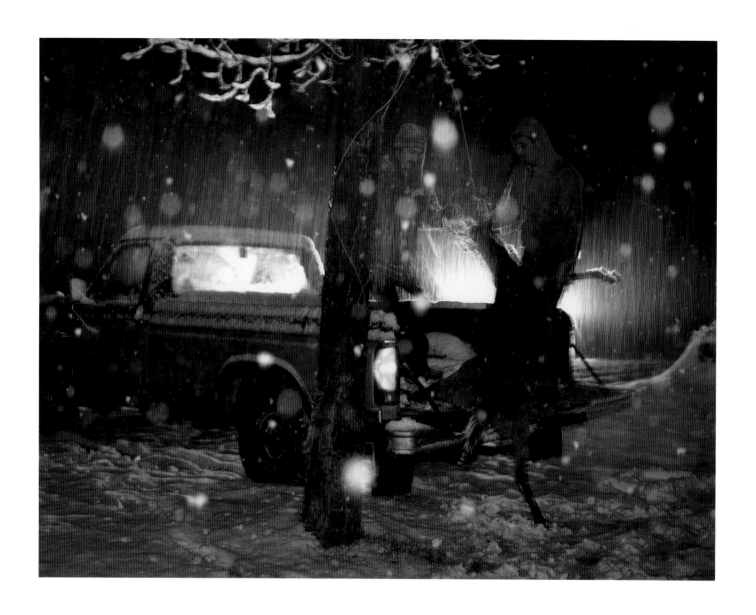

Back when my father used to hunt, it was the first 10 days of December. There be some snow on the ground, there be some cold in the air too. And maybe some blustery weather. That'll pick these mama's boys out, by Jesus sakes Chris'. You either hunt or else you don't sit down out there anyway. Shorten the season up. I wouldn't care if they didn't have only a week of it.

And sometimes I think . . . that's wrong. It's an all-out war in this state on that one animal. It's an all-out war on that white-tail deer. The poor inno-cent thing has got no defense, only to run. And that deer fears a man. But the last thing that deer will do, if he's in death's fear, he'll come right to ya. He wants your help.

—sawmill operator

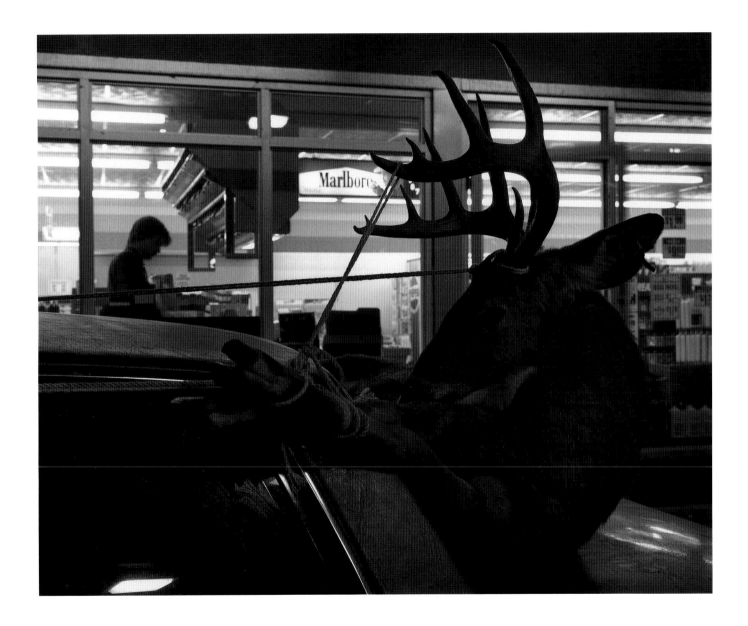

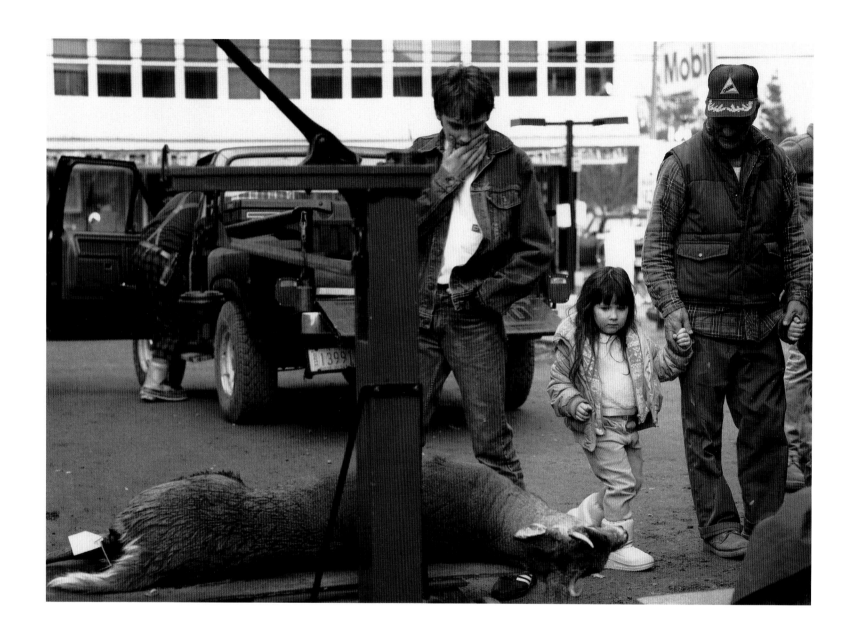

He'd always be coming home from hunting with something. He'd find . . . a small stone that had a fossil in it. And I oftentimes wondered "How the hell did you find something like that if you were looking for deer?" I think it was the whole thing with being out there, the smell, the environment, just alone and time to think and time to just reminisce. And he'd come home with a pocketful of beech nuts, which are the worst nut in the world to try to get into. And he'd say "Well, this is where I met this person." Every year they'd see, traditionally sometimes, the same people in the same spot. He had his favorite places where he'd go. And then he'd bemoan the fact that it was hunted out, usually by people that didn't know what they were doing.

—artist and gravestone designer

The priorities have changed. Wisdom and age and everything has been a part of that, I'm sure just like with anybody else. I get a thrill still out of shootin' a deer. But the priority of that thrill isn't there, I mean up so high as it used to be. I ain't here to impress them. I'm here because I'm having a good time. So jinglin' the grate and keepin' the fire goin', or cookin' something, or sweepin' the floor, or bullshittin' you guys has got a higher priority right now than me goin' out and killin' a deer.

—cabinetmaker

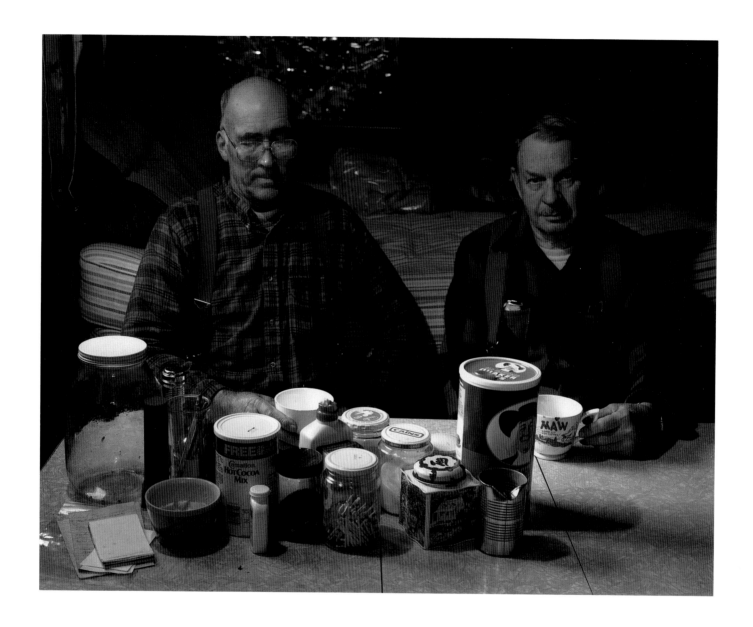

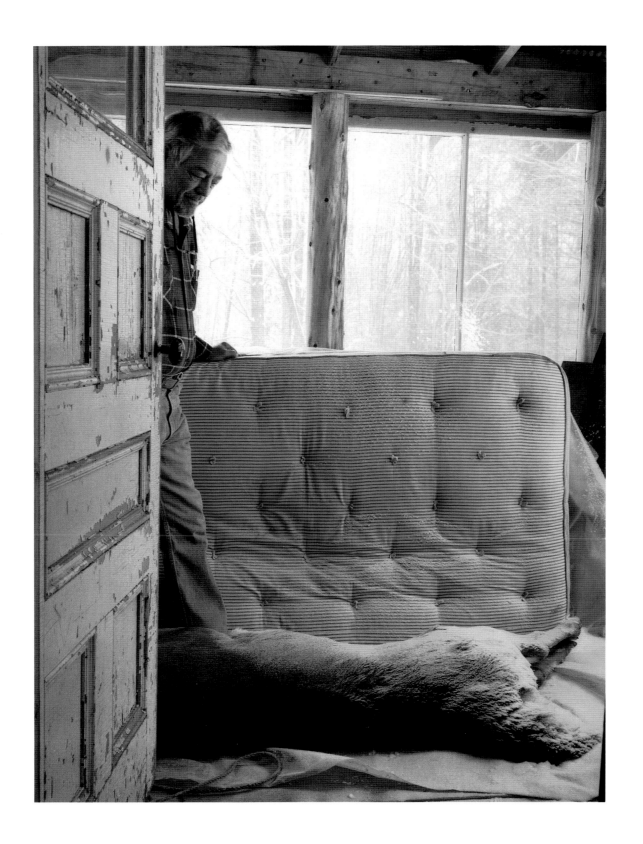

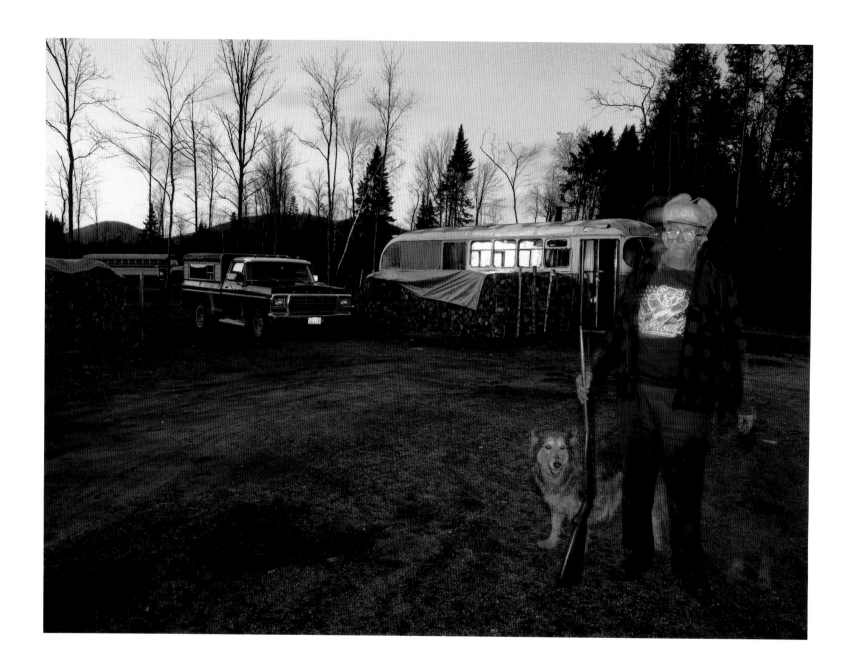

My father had a heart attack when he was 60 and was unable to drive. And do you know that every year he got his hunting license and we'd go, and we'd ride the back roads. Because you had to have a special permit to hunt from a car.

And I would just hope to God that he wouldn't get a deer. Because first of all, it really bothered me shooting them. Because to me they were objects of beauty. And then the next thing I thought is "My God, how would I ever drag this thing to the car?" But I think it was the act of going. And he used to go by himself and we'd just pray to God sometimes that he'd get back. Because he just didn't have the physical strength. But it was like as long as he could do that he knew he was alive. There was like some hope as long as he could go hunting every single year. And we'd ride those back roads, and . . . God only knows how we ever managed to drive through some of those places. . . .

Usually at least three or four times every week, during the deer season, he'd have his gun, I'd have my daughter, my baby, . . . and we'd strap her into her car seat and off we'd go. And he'd have these . . . certainly not a vehicle that was good for going down some of these old logging roads. And he always liked it when there was a little bit of snow, because then, of course, you could see the tracks. That was when I was more terrified, because it would cover the ruts in the roads and you wouldn't know what was there. And then he'd insist on getting out and walking in a little bit, places where he had gone before.

He was familiar, he knew the territory like the palm of his hand. But on the other hand I didn't. And I certainly wasn't used to driving a lot of those places. But he'd get very upset if I'd say "I really don't want to go down here, Dad. Let's try some-place else." "Oh, for chrissakes, just keep goin'. You'll be okay, don't worry about it." There was never an issue with him. We never got stuck, thank God. But sometimes, I think it's a miracle that we didn't. And I used to be a little afraid with his rifle in the back seat, next to my daughter. But I often-times think it probably wasn't even loaded. I wouldn't be surprised if it wasn't even loaded.

—*artist and gravestone designer*

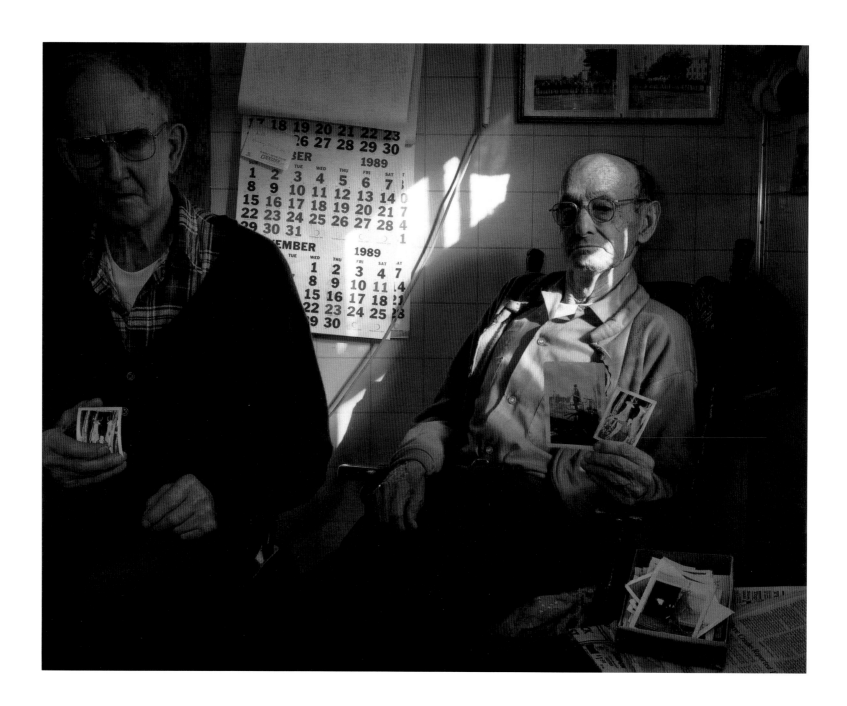

When The Roll Is Called Up Yonder

When the roll is called up yonder
And my hunting days are done
Leave me lay out on some hillside
Where the ole red foxes run
Leave me lay back from the hillside
Where the traffic sounds are not
Where the noisy sounds of progress
Cannot reach my resting spot
Make it where no greedy grasping hands
Will reach to grasp their fill
Make it where all greed's a stranger
On some quiet peaceful hill
Make it by a speckled trout stream
On a hill that greets dawn's sun
Where dedicated houndsmen
Will bring their hounds to run
Make it by some hardwood forest
So that in the fall
The colored leaves will caress this spot
When from the frost they fall
Leave me lay beside the game trail
Where the mightiest whitetail trod
Let it be where just the mightiest
Leave their hoof print in the sod
And make it where the cross winds
Will blow which ever way

It takes to bring the baying sounds
Of the hounds that pass that way
Make it where the warming sunshine
Brings the earliest signs of spring
Leave me lay beside the tallest elm
Where first the robins sing
Make it far back in the country
When to rest you lay me down
Leave me lay there ever after
'Neath the peaceful country sounds

—hunter, poet, and songwriter

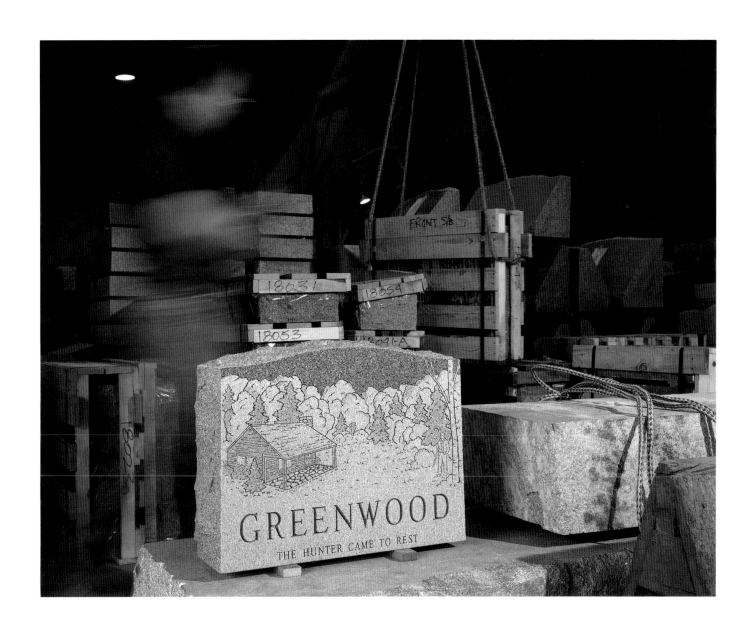

My last visit is to the home of Hector, a logger who, although better known for his fishing prowess, has hunted deer since moving down from Canada as a child. Raised on a farm in northern Vermont, he now logs with his son. In the fall it is firewood and brush for Christmas wreaths; in the spring it is cedar fenceposts. It's cold enough to prompt an invitation into the kitchen for coffee. There is a classic white enamel wood stove, every burner occupied. Boots reflecting a diversity of chores, from slopping pigs to handling chainsaws, skirt the stove's base. An equally diverse collection of hats, including an orange hunting toque with a deer emblem, hang on the wall. Next to the headgear is a calendar with a photograph of a buck. Atop the television in the living room is a lamp whose base is a ceramic recumbent fawn. Resting on the enameled warming shelf above the stove is a plastic light-up Virgin Mary, whose humble pose keeps the deer idolatry at bay.

Looking at the calendar, with its color picture of a majestic buck in a stand of birch, I am struck by how deer can figure so prominently in these people's lives. With the past two weeks I have visited camps, homes, and every imaginable sort of public or private space in northern Vermont. Virtually everywhere, I have discovered a density of imagery and crafted objects referring to deer and the woods. In hunting camps and in homes, verbal narratives in hunting stories, logbooks, journals, and even poetry describe deer hunting.

Every cemetery I have visited has had at least one gravestone depicting a deer, and often there was a hunter in the scene.

For the people I have interviewed and photographed, hunting is a part of the seasonal cycle that also includes fishing in the winter and spring and growing vegetables in the summer. Their living and work spaces reflect the wholeness of a life oriented toward natural things.

What does all the deer iconography represent? How might this tradition relate to the prehistoric cave paintings of deer or to the illustrations of deer found throughout the material culture of Native Americans? Does it suggest fascination with or respect for the hunted animal, or does it reflect a longing for a more pastoral and natural time?

A mounted deer head, an ordinary old rifle with faded bluing, a scrapbook, an album of snapshots—what can these fragments from life offer the observer? At first, I thought these mementos and knickknacks were merely decorative. Now, as I watch Hector wiping aromatic oil on his rifle, I realize that, for the participant, the objects and stories that constitute hunting lore are symbols of a multi-faceted way of life in which the past is meaningfully connected to the present. From my travels, I have learned that hunting camp is as much located in one's mind and imagination as on a gentle, sloping knoll on the southern exposure of Gore Mountain.

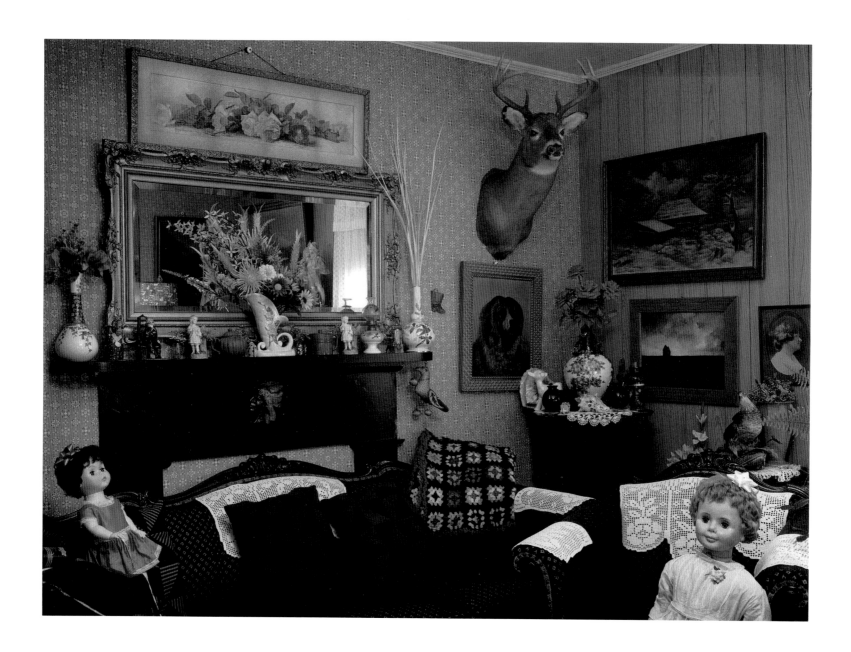

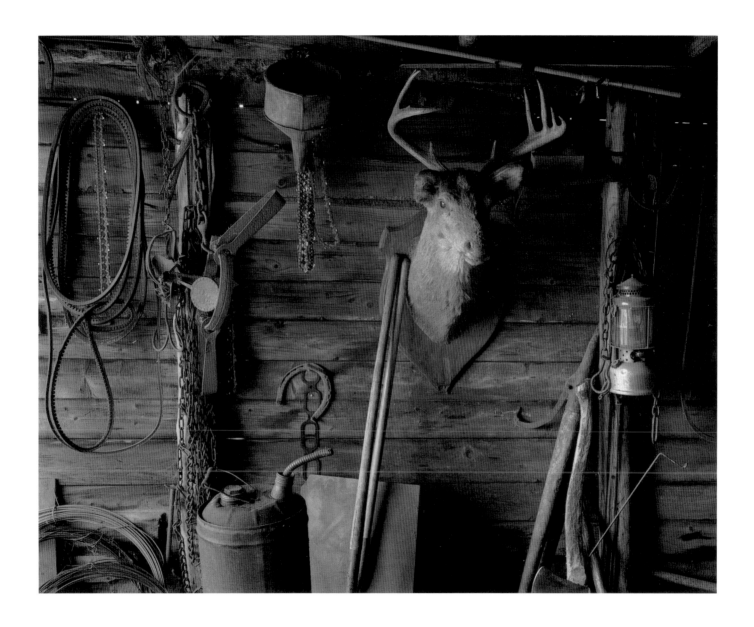

John Miller's photographs and text reveal in abundant detail that in Vermont deer camp is both a place and a way of life, representing a time of year when the calendar is turned back to an earlier day—as much as that is possible in the modern world. There are traditions, skills, techniques, a body of lore, food, companionship, architecture, artifacts, stories, and humor, all tied to a personal quest to triumph in nature, on nature's terms.

Deer camp may seem beyond the ken of many Vermonters, but that way of life confronts most of us periodically and unexpectedly. Along with the first Tuesday in March (Town Meeting Day), those two weeks in November, lasting through Thanksgiving weekend, are considered sacrosanct by some. Anything that breaks down will have to wait until the season is over before it is fixed. Electricians, plumbers, and carpenters are in scarce supply. One business contractor did not understand about the importance of those two weeks and tried to give everyone summer vacations. He discovered most of his employees contracted a strange virus in November from which it took about two weeks to recover.

Everywhere during those sixteen days there are indications of deer season. A dog's orange collar or two fluorescent ribbons tied on the ears of a horse, lest these animals be mistaken for deer. (Stories abound of out-of-staters not being able to distinguish a cow from a deer.) Cars with cavernous deer carcasses strapped to the hood. The local radio report from the official weighing station. An influx of pickup trucks on back roads. Figures garbed in red-and-black checked jackets, rifles in hand, trudging toward a parked vehicle. All these things remind us visually of the season.

Deer hunting may be considered the darker side of Vermont life by those who were brought up downcountry or who cut their teeth on Disney's *Bambi*. But here it remains a strong vestige of a rural way of life which is tied closely to the land and to the seasons. It is a heritage that many feel is important to maintain, and one that is nourished within the family and across generations. In the past, work and play were not viewed as distinct but were extensions of one another. Hunting and fishing were enjoyable, but they also placed food on the table. During the Depression, deer meat

and home produce enabled many families to survive. Even today in the Northeast Kingdom this is a reality for some.

Deer hunting remains largely but not exclusively a male activity. Along with the hunt comes a physical regimen, keen observational powers, and frequently a profound knowledge of the woods. A boy usually begins his training at a young age, learning how to track and read the various signs—where a buck has rubbed his antlers on the trunk of a tree, evidence of browsing, of deer beds and deer crossings. With this knowledge comes a range of lore about other animals and their habits, about trees and plants, and about the weather. More than anything, the emphasis is on the elusive quarry and the hunt: the skill of finding a deer, tracking it, and finally triumphing over it.

When hunting was a significant means of putting food on the table, the killing of a boy's first deer was more akin to a rite of passage. Blood from the carcass would be smeared on his forehead. If he missed, his shirttail would be cut off. Today, with hunting and the attendant woodslore no longer important to survival for the majority and indeed often misunderstood by those who have grown up under urban or perhaps suburban conditions, it has come under a great deal of censorship. The killing of the deer is seen as the central focus and termed cruel and barbaric. But in reality it is much much more than that single act. Indeed there is killing—and in the best of all possible circumstances a single shot will fell the quarry, demonstrating skill in marksmanship as well as humanitarianism. The fact remains, there are those who return to the woods each year to participate in the ritual of the hunt, with all that entails, and to test their mettle against nature and the out-of-doors.

Deer camp is enjoyed as a way to get back to the basics. Comforts are few—no electricity, no plumbing. Great pleasure is taken in the companionship of those in camp, and for a brief time the outside world is kept at bay. It is one of the few opportunities to partake of a way of life that has disappeared and to retreat from civilization to pit oneself against the wilderness, a contest where man loses more often than he triumphs.

For the hunter who has grown up in the tradition, deer hunting is a quest after a noble adversary. Even if he does everything right and has learned all the lessons of the wilderness well, many a hunter will go the entire season without so much as seeing a buck. The story is told of a hunter's brother who was not keen on hunting deer. He thought hunting was highly overrated

and that there was nothing to it. His brother persuaded him to come into camp. The novice slept late opening morning, while the rest of the camp was up before break of day. As he arose after a good sleep, he happened to look out the window, and saw a deer standing there. He picked up his gun and shot the buck. When his brother returned weary from a day of hunting and no glimpse of a deer, the greenhorn greeted him with "Well, I still don't think there's anything to this hunting." He left camp the next day.

The humor in this is that the interloper has done everything wrong, has broken all the codes of behavior, and has no idea of his incredible luck.

It is in the story of the hunt, however, that raconteurs wax eloquent. In their narratives they evoke emotions that hold the listener. Each season's new hunting incidents are turned gradually into camp legends, recited again and again by the gathered fraternity. These tales take in the comedy, the pathos, the skill of pitting oneself against a heroic and wary opponent—but, more than that, the awareness of being outdoors, a sense of self-reliance, and an appreciation of that world.

The two weeks in camp are also remembered with great nostalgia during the rest of the year. Antlers line a wall, a hooked rug of a boy's first deer lies on the floor, a photograph of the hunting camp and its occupants sits on the bureau. It is a sacred time— a means to keep oneself in touch with a more elemental existence. It is a lifelong pursuit.

Recently a stonecarver finished a tombstone at the request of his sister and brother-in-law. On the granite piece is pictured their hunting camp, which all the family pitched in and helped to build two miles back in the woods some forty years ago. A sign reading "Rora-shel" (a combination of the husband's and the wife's names) identifies the camp. The stone awaits the couple in Hope Cemetery. It stands as a significant symbol for the family as a whole. For them as for so many other hunters, deer camp remains as the embodiment of a way of life that places a man once more—at least in his mind's eye—on Vermont's last frontier: the backwoods, where he alone is responsible for his livelihood and all that that quest entails.

Jane C. Beck
The Vermont Folklife Center